With our
love to:
Jane
on
Christmas, 1989
Mom and Dad

THE PAINTINGS OF MATISSE

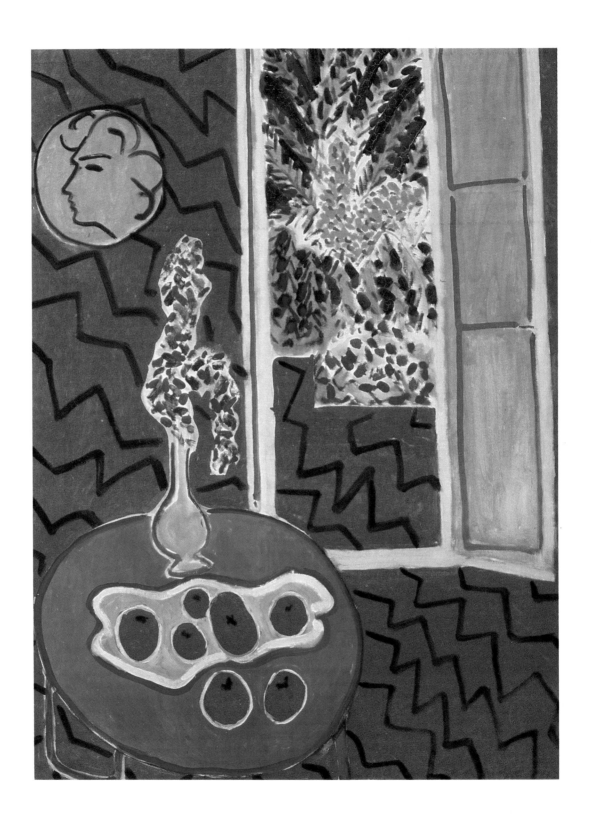

THE PAINTINGS OF MATISSE

Douglas Mannering

MALLARD PRESS

Front cover: *Self Portrait*, 1918.
Musée Henri Matisse, Le Cateau.

Frontispiece: *Red Interior, Still Life on a Blue Table*, 1947.
Kunstsammlung Nordrhein-Westfalen, Düsseldorf.

MALLARD PRESS

An Imprint of BDD Promotional Book Company, Inc.
666 Fifth Avenue
New York, N.Y. 10103

Mallard Press and its accompanying design and logo
are trademarks of BDD Promotional Book Company, Inc.

ISBN 0-792-45010-8

Printed in Spain by Cayfosa, Barcelona

CONTENTS

MATISSE
AND THE
TWENTIETH CENTURY

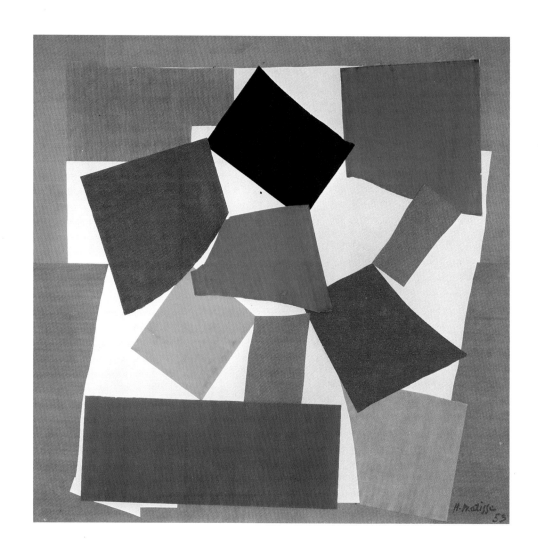

Henri Matisse has long been recognized as one of the greatest masters of the 20th century – one of its supreme colourists and the creator of a serene, harmonious, pleasure-giving art. Like Pablo Picasso, with whom he has often been compared, Matisse was one of the founders of modern art during the first revolutionary decade of the present century; and, again like Picasso, he outlived the scandals that ensued, and went on developing throughout a long life that culminated in a creatively fruitful old age. As well as employing a range of styles from late 19th-century Impressionism to an almost pure abstract art, Matisse worked with outstanding success in a variety of media. He was a painter, a printmaker – monotypes, lithographs, etchings, woodcuts – a book illustrator, and a costume and stage designer. Towards the end of his life he was able to create something close to the artist's dream – a total work of art in the Chapel of the Rosary at Vence, where every item from the chasubles to the stained glass was designed by Matisse alone. Finally, in old age, when he was often incapable of painting, he succeeded in creating a pleasing and sometimes moving kind of decorative art by the simplest of means: cutting pieces of coloured paper into shapes and pasting them on to a surface to form a design.

Such a catalogue of achievements gives an impression of dazzling, effortless virtuosity – an impression that in Matisse's case turns out to be more than somewhat misleading. As an artist he was in fact painstaking, cautious, patient and ceaselessly industrious, virtues more often associated with the *bourgeois* than with the revolutionary. Most of his important works were the result of long meditation and many preliminaries; one famous painting, *Pink Nude* (1935), was photographed at each stage of its creation by Matisse, who thus left to posterity a record of all the *twenty-two* versions he made before satisfying himself. Stylistically, too, he developed quite slowly, often making a number of tentative new departures for some time rather than committing himself all at once to a particular direction. Years sometimes elapsed before Matisse absorbed a new experience – a place, a non-European art form, a new style – thoroughly enough to make use of it in his own work. In many respects he remained strongly attached to the traditions of the past, and even to its values. For those who regard the 20th century as essentially a tragic period, Picasso's *Guernica* and the attenuated, anxiety-ridden sculptures of Alberto Giacometti seem 'modern' in spirit, whereas Matisse's art, despite his audacious colours and extremely stylized figures, seems to belong to a more stable, untroubled world in which pleasure is not a refuge but a legitimate, eagerly sought end in itself.

Whether as myth or reality, that carefree world disappeared with the World War of 1914–18 and has been the subject of an intense nostalgia almost ever since. However, Matisse's art is certainly not dominated by nostalgia, and its untroubled, harmonious character seems old-fashioned or 'irrelevant' only to people with a blinkered and simple-minded conception of art. Nevertheless, Matisse was in some important respects a man of the 19th century, and this fact explains a good deal that we have already said about his development.

THE SNAIL

A paper cut-out verging on the abstract.
1953. Tate Gallery, London.

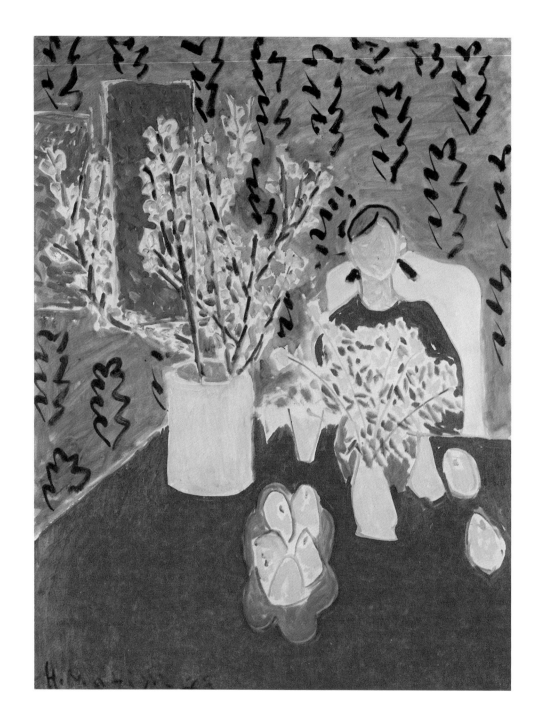

PLUM BLOSSOMS AGAINST A GREEN BACKGROUND

The brilliant pink and yellow blossoms demonstrate Matisse's ability to contrive
colour explosions in his pictures.
1948. Private collection, New York.

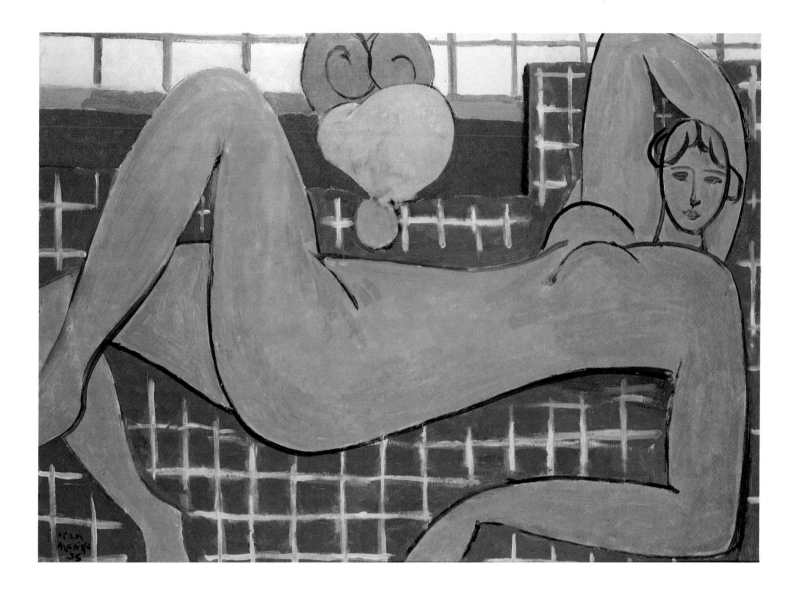

PINK NUDE

The large simplicity of this painting was in fact achieved only with considerable labour. A series of twenty-two photographs of the work in progress indicates how many false starts and changes of direction Matisse suffered before the final conception.
1935. The Baltimore Museum of Art, Cone Collection.

To begin with, he was born as long ago as 1869, almost twelve years before Picasso. Even as a late starter, aged twenty-two, he entered an art world still dominated by official academies and exhibitions; his earliest lessons were in the academic tradition of a strict technical accuracy that excluded anything in the way of experimental or expressive work. For while the art establishment had been challenged by new tendencies, such as Impressionism and Pointillism, since the 1870s, it had by no means capitulated, although first-generation Impressionists such as Monet and Renoir had become fairly respectable; the more radical, 'Post-Impressionist' painting of Cézanne, Van Gogh and Gauguin was hardly known.

In the 1890s Matisse moved slowly away from academic art, and through Impressionism towards a bolder colouristic art. After dallying with the 'dotting' technique of Pointillism, he emerged into public consciousness in 1905 as leader of the 'wild beasts' – the Fauves – whose raw colours and 'childish' compositions set off the first great artistic scandal of the 20th century. By this time Matisse, now a figure of controversy – hero to some and target to most – was no youthful rebel but already a mature man of thirty-five.

Origins are notoriously difficult to pin down in time, but there is a good case for regarding the Fauve scandal at the 1905 Salon d'Automne in Paris as the foundation-event of modern art. What made the Fauve style modern was the way in which the artist interpreted the relationship between his work and the world around him. For several centuries, paintings and sculptures in the West had been essentially representations of the physical world as it appeared to the eye, albeit modified by various conventions and filtered through the temperament of the individual artist. By contrast, modern painters and sculptors since the Fauves have seen themselves as autonomous – as creators of objects that possess their own internal logic and significance. For such artists, a work of art is something new in the world, not a mere copy; they may exploit our knowledge of external reality, but they recognize no obligations towards it. This change of outlook was summarized by Matisse himself, when he was asked about the way he painted women: 'I don't paint women,' he replied. 'I paint pictures.'

Inevitably, Fauvism had its predecessors. By the beginning of the 20th century, artists were becoming familiar with the work of the Post-Impressionists, many of whose paintings were at least implicitly autonomous, and with African and other non-Western arts, which made a profound impact precisely because their artistic force owed nothing to Western conventions of representation. Given these stimuli, the modern revolution took place with astonishing rapidity. In 1905, Matisse and the Fauves proclaimed the autonomy of colour, employing it quite arbitrarily (from a realistic point of view) in the interests of expression or design. From about 1907 Picasso and Braque were carrying out an equivalent operation on artistic forms; Cubism, which involved taking apart and reassembling reality according to its geometric constituents, led on to a host of formal and expressive experiments in which 'reality' as a criterion disappeared. By about 1910 the Russian painter Wassily Kandinsky was coming to the conclusion that a picture need not even have a recognizable subject; and so he went on to paint the first abstract – that is to say, an autonomous work of art in which no attempt has been made to exploit the spectator's knowledge of the world beyond the picture surface.

In a sense, then, the modern revolution was accomplished in the first decade of the 20th century, and everything that followed – an exciting proliferation of new schools and styles and techniques – can be interpreted as a working out

THE INVALID

A freely painted early work in late 19th-century style. The subject is Madame Matisse, who was taken ill while she and her husband were staying at Toulouse. 1899. The Baltimore Museum of Art, Cone Collection.

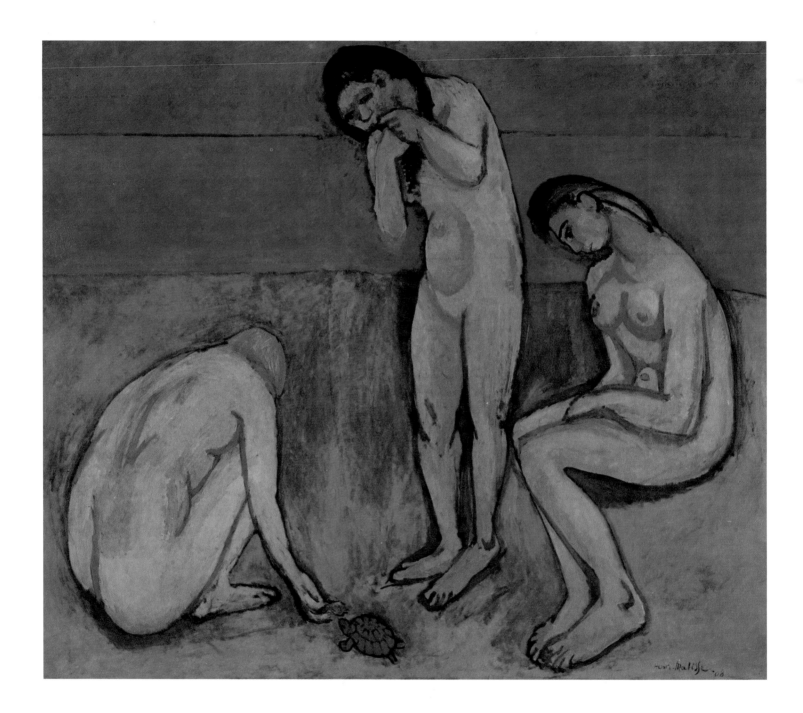

BATHERS WITH A TURTLE

The background has been simplified into horizontal strips of sand, sea and sky,
with all attention focused on the creature in the centre.
1908. City Art Museum, St. Louis, Missouri.

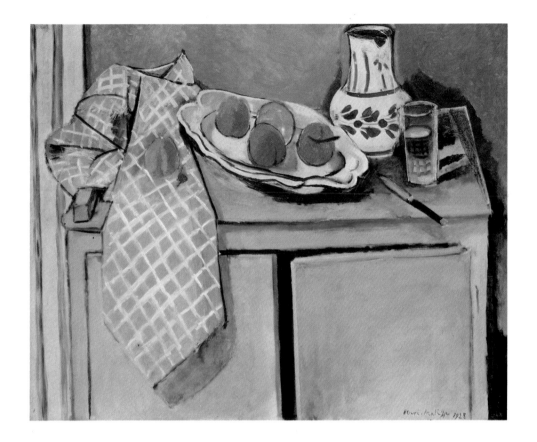

of possibilities that had been present in the art of Matisse and the other 'founding fathers'.

The Fauve liberation of colour was Matisse's most significant achievement as an innovator, although his finest work as an artist was yet to come. For a good many years he was a 'wild beast' in the eyes of the general public, but the support of perceptive patrons (oddly enough, almost all of them Americans and Russians) enabled him to paint without material worries and to undertake large-scale commissions that called forth all the resources of his art. Within a short time he had abandoned the fierceness of the Fauve style,

although colour remained the most forceful element in his work. Colour makes the most immediate impact on the senses, and Matisse was above all a sensualist in his approach to art; but his sensuality was of a kind that almost always excluded the problematic and trouble and turbulence. He himself stated, no doubt with conscious mock modesty, that he dreamed of a pure, tranquil art, free of disturbing subjects, that would soothe the mentally fatigued as effectively as . . . a good armchair. This does in fact convey the predominant mood of Matisse's work, if not the largeness of vision that imbued purity and

STILL LIFE WITH GREEN BUFFET

Shows the influence of Cézanne, whom Matisse greatly admired.
1928. Musée National d'Art Moderne, Paris

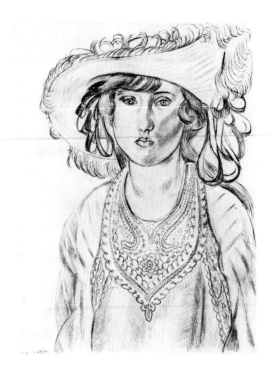

tranquillity with the 'almost religious feeling' about life that Matisse also wished to express. *Luxe, Calme et Volupté* (roughly 'Luxury, Tranquillity, Pleasure'), *The Joy of Life, The Dance, Music*: the very titles of some of Matisse's most famous works suggest the visions of an earthly paradise that seem to have haunted him.

Within the boundaries of his temperament, Matisse discovered apparently unlimited territory to explore and make his own; at the end of a long life, almost fifty years after his first notoriety as leader of the Fauves, he was as creatively fertile as ever. He had no real taste for public controversy and, even before the outbreak of the First World War, had shown a disposition to get away from Paris, either by taking refuge at a summer villa or through foreign travel. From 1916 he spent an increasing amount of time at Nice, where the warmth and colour of the South inspired him to paint some of his most straightforward scenes

of private pleasure, which helped to make his art relatively popular between the World Wars. However, so far from working a single vein for the rest of his life, Matisse struck out in several directions, moving restlessly between painting styles and also experimenting in new media. Tranquil and harmonious as any individual work of Matisse's may appear to be, his art as a whole was subject to conflicting and insistent impulses – towards ever greater simplification but also towards an 'Eastern' ornamental density; towards pure decoration on the one hand and, on the other, an expressive, emotionally significant art. Neither in his works nor in his theoretical statements did Matisse resolve these contradictions, which were almost certainly stimulating to the artist, however much they may have agitated the man. Matisse's art, for all its homogeneity of mood and apparent simplicities, is as complex and subtle as its classic status suggests.

THE PLUMED HAT

One of a series of drawings in which Matisse portrayed the same model.
1919. The Baltimore Museum of Art, Cone Collection.

GIRL IN A YELLOW DRESS

This was begun before Matisse's visit to Tahiti and completed at Nice after his
return from America.
1929–31. Baltimore Museum of Art, Cone Collection.

QUIET
BEGINNINGS

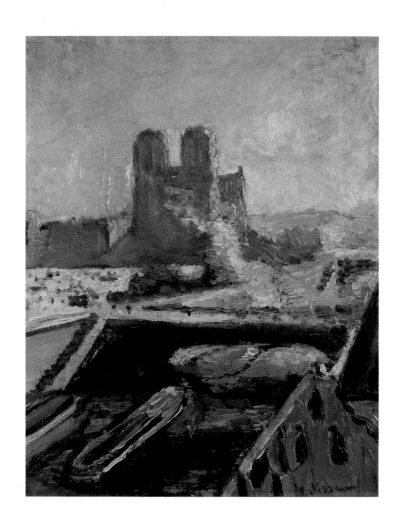

Henri Emile Benoît Matisse was born on the very last day of the year 1869, in his grandparents' house at Le Cateau-Cambrésis, a small town in the far north of France, about thirty miles from the border with Belgium. He was brought up in his parents' house in the still smaller town of Bohain-en-Vermandois, where his father, Emile Matisse, had established himself as a prosperous grain merchant. Matisse, then, was a Northerner, from a flat, rather uninspiring region of France in which the presence of agriculture and industry was more strongly felt than either local colour or artistic culture; his love of bright pigments and the brilliant South can be explained as a reaction against his environment, but certainly not as an inheritance.

Matisse was sent to a local primary school, from which he went on to the *lycée* at Saint-Quentin, a somewhat larger nearby town. Few details of his schooldays and early manhood are known, but there is nothing to suggest that he knew or cared anything about art before – at the earliest – his late teens. Most great artists have drawn and studied from an early age, even if their conviction of a vocation has been late in coming; Matisse's case may well be unique. In the autumn of 1887 his parents sent him to study law at the University of Paris, and he worked diligently enough to pass his examinations at the first attempt; in old age, he claimed to have taken his studies lightly and to have spent much of his time at France's great museum, the Louvre, but if so its influence on him was not immediately apparent. By 1889 he was back at Saint-Quentin, finishing his training by working as a clerk in a lawyer's office. At twenty, Matisse might have been taken for an average young man who could be expected to make an adequate, obscure career for himself as a provincial attorney. One prank of Matisse's, which he enjoyed recounting in later years, vividly evokes the Dickensian dullness of clerical work before the typewriter had come into common use as a labour-saving device. A great part of his work consisted of routine copying of documents; since most of them were never consulted, but only served to give clients' dossiers the dignity of bulk, Matisse entertained himself by ignoring the documents and copying out the fables of La Fontaine – evidently without his substitution ever being discovered.

The first turning-point in his life occurred in 1890 when he fell ill with appendicitis. During his convalescence he bought himself a box of colours and a standard text, Goupil's *General Manual of Oil Painting*, and began his career as an artist by copying reproductions of Swiss landscapes and other popular scenes. Soon he was painting his first original picture (a still life) and getting up early each morning to spend a precious hour before work – from seven to eight a.m. – drawing from plaster casts and taking instruction from the masters at the Saint-Quentin school of tapestry and textile design. Matisse was instantly and permanently captivated by his first creative experiences, but evidently his parents were not easily convinced that he should abandon a respectable career in the law for a will-o'-the-wisp. It was the autumn of 1892 before Matisse finally arrived in Paris, with an allowance from his father, to study art. He was almost twenty-three years old.

NOTRE-DAME

The view from Matisse's Paris studio included the famous Gothic cathedral.
c. 1900. Tate Gallery, London.

In retrospect we can see clearly that Paris was the art capital of the Western world for most of the 19th and 20th centuries. Until the Second World War 'the school of Paris' was the centre of most great movements in art, attracting and nourishing not only aspiring provincials such as Henri Matisse but also foreigners of genius like Vincent van Gogh and Pablo Picasso. Realism, Impressionism, Pointillism, Fauvism, Cubism, Surrealism – the history of art in 19th- and 20th-century Paris seems like one long, joyous riot of subversive 'isms'.

To those who lived through it, the situation seemed less clear. In 1892, as in the earlier part of the century, French art was dominated by official and semi-official academies and exhibitions (*salons*); some accommodation had been made with revolutionary doctrines such as Impressionism, but what we now call 'academic art' remained the norm for both the general public and the career-minded artist. In each generation, most young men of talent came to Paris with the intention of studying under some reputable and recognized teacher; but sooner or later the more perceptive of them realized the emptiness of academic art, and the more daring of them sacrificed their career prospects by initiating or joining some more vital movement. The young Matisse behaved much like everybody else, arriving in the capital with an introduction to the renowned Adolphe William Bouguereau, one of the most bemedalled of all academic painters; Matisse found the great man surrounded by his admirers, who were congratu-lating him on completing a *third* copy of his 7 ft (212 cm) high, 5 ft (152 cm) wide and universally acclaimed *Invading Cupid's Realm*. Bouguereau's paintings exemplified the chief qualities of aca-demic art: they were technically superb, highly polished and utterly banal; the subject-matter, consisting of sickly-sentimental or emptily rhe-torical scenes from mythology or history, was escapist in the worst sense of the word. And although not all academic painters were as slickly vapid as Bouguereau, the required mechanical perfection of technique and conventions of senti-ment set up an almost insuperable barrier to really significant achievement. Despite an unfavourable first impression, Matisse enrolled at the Académie Julian, a teaching academy staffed by Bouguereau and other professors from the national school of art, the Ecole des Beaux-Arts; no doubt Matisse expected his course at the Académie Julian to prepare him for the Beaux-Arts' entrance examination, in which a pass would open the way to a conventionally success-ful career. But it was not to be. Matisse, later famous for graphic works in which a few lines express the essence of a subject, was actually told by Bouguereau that he would never learn to draw; the pernickety teaching and meaningless routine copying exasperated him, and he left the academy.

His sense of vocation seems to have been reawakened by looking at the paintings of the great Spanish master Goya – not, as one might suppose, at the Louvre, but in a museum at Lille.

WOMAN READING

This pleasant but conventional painting was Matisse's first public success. When exhibited in 1896, it was purchased by the State for the President of France's country residence.
1894. Musée National d'Art Moderne, Paris.

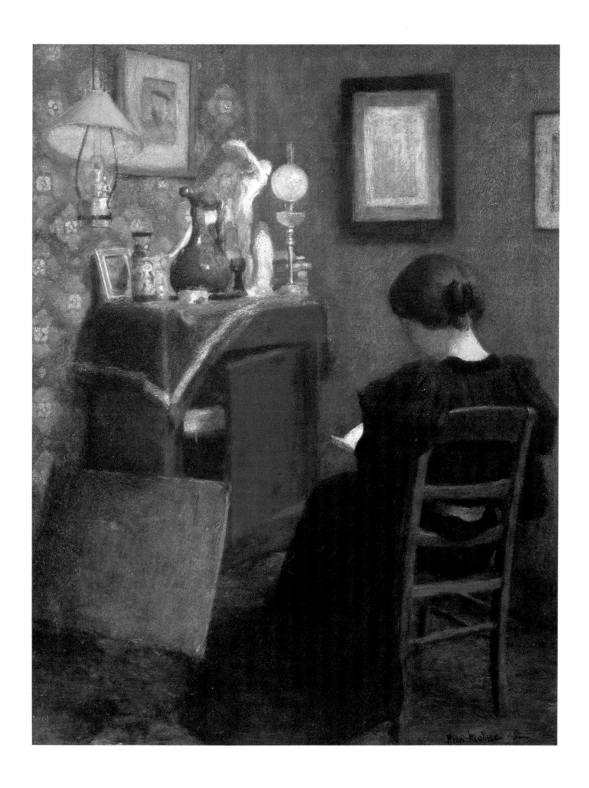

Here, Matisse felt, was a bold and serious art that was worth emulating. All the same, his intentions remained conventional enough. He now worked independently in the glass-covered court of the Ecole des Beaux-Arts, where plaster casts of ancient Greek and Roman statues served as models. One of his reasons for doing so was that the Beaux-Arts professors often strolled through the court and might just be persuaded to take up a student there whose work showed promise. Matisse set out to attract the attention of one in particular, Gustave Moreau, whose teaching he had heard praised; he succeeded, and Moreau invited him to join his class, despite the fact that Matisse had not passed the necessary examinations. This proved to be a stroke of great good luck, for Moreau was quite exceptional among the Beaux-Arts teachers in the breadth of his outlook and in his tolerance of those who differed from him. Although quite orthodox in his technical standards, he held that self-expression was the artist's first duty, and therefore encouraged instead of repressing his pupils' individuality. In later life Matisse always spoke of Moreau with affection and respect, recalling his charm and the enthusiasm with which he discoursed on the qualities of the great masters. Significantly, Moreau himself sometimes transcended the limitations of his own academic technique, making his biblical subjects a vehicle for intensely imagined fantasies; the most famous example was his *Salomé*, a painting executed in distinctively jewel-like colours, which the 'decadent' writers of the 1890s greatly admired.

Moreau encouraged Matisse to improve his technique by the time-honoured method of copying master-works in the Louvre. This could also be a source of extra income for students, since good copies were much in demand in the days before photographic reproductions, and the government itself was prepared to buy; however, according to Matisse, the mothers, wives and daughters of the attendants were more commercially successful than the students, since they were more painstakingly literal copyists. Moreau also advised Matisse to go out into the streets and draw what he saw there – a practice followed by many great artists, but one rather frowned upon by 19th-century academic teachers obsessed with detail and finish; like Bouguereau, they believed that sound technique could only be acquired by painstaking work in front of a plaster cast or studio model. The streets, said Matisse, were where he learned to draw; a favourite working place was a cabaret called Le Petit Casino, from which he and Albert Marquet tried to execute lightning sketches of the passers-by.

Marquet was Matisse's closest friend at the studio. He was a myopic, rather withdrawn but nevertheless sharply observant character; six years younger than Matisse, he was, if anything, the more experienced of the two, having been an art student since his middle teens. Though never a true Fauve, Marquet was to exhibit with Matisse at the scandalous 1905 show, and in later years he and Matisse worked and travelled together from time to time. At Moreau's studio Matisse also met the future Fauves, Henri Manguin and Charles Camoin, and two painters who were to become much better known, Georges Rouault and Raoul Dufy. Matisse's memory may have been at fault in placing his first meeting with Dufy at the Beaux-Arts; at any rate they cannot have worked side by side in a class, since their dates of attendance do not overlap. Rouault had no significant connection with Fauvism, although for a time the aggressiveness of his style deceived the French public into thinking so; he was essentially a religious painter, his characteristic works displaying a dark richness of colour and distinctively heavy outlines reminiscent of stained glass – a craft to which he had been apprenticed as a boy.

Dufy, on the other hand, was definitely influenced by Matisse's Fauvism around 1905, before developing his own colourful style.

At this stage in Matisse's career, no one would have predicted the kind of influence he was later to exert. His early paintings consisted of interiors and still lifes executed in the most uncontroversial of manners – quiet in colour and peaceful in mood – which made them 19th-century equivalents to the works of the Dutch old masters and the 18th-century French painter Jean-Baptiste Chardin, whom Matisse especially revered. For a time it even seemed that he might know the pleasures and dangers of early success. Four of his paintings were accepted for exhibition by the important Salon de la Nationale in the spring of 1896 and as a result two were sold; one, *Woman Reading*, was bought by the State and hung in the Château de Rambouillet, the summer residence of the President of the Republic. Then, immediately after the exhibition, Matisse was elected an associate member of the National Society that had held the salon, having been proposed by the president of the society, the famous painter Puvis de Chavannes. At twenty-six, after a late start, Matisse appeared to be launched on a respectable and successful career.

Shortly afterwards, however, subversive influences began to appear in his work. The Impressionists had begun painting outdoors and using bright, unmixed colours over a quarter of a century earlier, but Matisse either did not know or could not understand their work, let alone the work of Van Gogh and the Post-Impressionists, or that of still more recent decorative painters such as Maurice Denis and the Nabis; this fact is a particularly vivid instance of the gulf that separated the established and avant-garde worlds in Paris. Matisse began to paint outdoors in about 1895, but his first inkling of the role that colour might play in a picture occurred during the summer of 1896, when he went on a painting trip to Belle-Ile-en-Mer in Brittany with his friend and neighbour Emile Wéry. Matisse noticed that Wéry, a minor artist who had been influenced by Impressionism, employed pure primary colours on his palette and achieved effects of luminosity that seemed to be beyond Matisse's old-master technique. According to one account given by Matisse, he rapidly acquired a passion for 'rainbow colours' whereas Wéry was converted to Matisse's sombre palette – an entertaining if too-neat-to-be-true story. In reality, Matisse's conversion was rather more gradual. In the following spring he experienced the full impact of Impressionism when the Caillebotte Bequest was put on show at the Musée du Luxembourg; this was the first collection of Impressionist paintings to be acquired and exhibited by the State – against considerable opposition from professors at the Beaux-Arts and other reactionaries. During another summer in Brittany he met the Australian Impressionist, John Russell, who reminisced about his friend Claude Monet and presented Matisse with two drawings by Vincent van Gogh. And at some point in the year he met the sixty-seven-year-old Camille Pissarro, a veteran Impressionist and the one most accessible and most gifted as a teacher; as well as explaining the history and technique of Impressionism, Pissarro introduced Matisse to the work of Cézanne, and also advised him to study the paintings of Turner in London, doubtless remembering his own stay in the city during the Franco-Prussian War of 1870–71. These and similar influences worked on Matisse gradually but surely, prompting him to explore the possibilities of colour and his response to the natural world.

In the spring of 1897, Matisse showed *The Dinner Table* at the Salon de la Nationale. This large painting was in part a response to Moreau's insistence that he should do something really

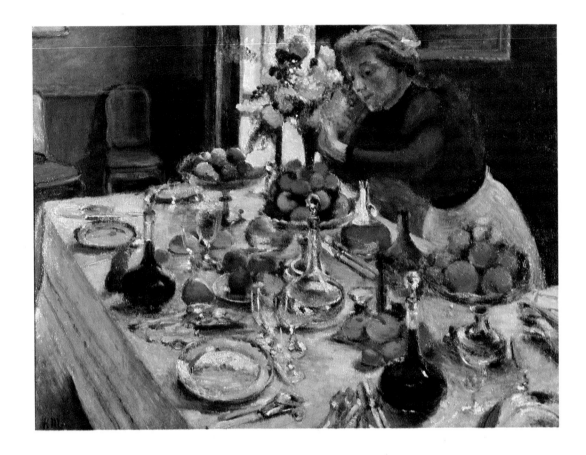

substantial; the 19th century, obsessed by size, expected its painters to stake their claims to attention in some such fashion. *The Dinner Table* created a stir, but mainly one of disapproval: it was evidently too Impressionistic for most of the members' taste, although, having made Matisse an associate, they were powerless to prevent him from exhibiting the work at the salon. In fact, Matisse's Impressionism was, as yet, a modest enough affair: his colours were brighter than before, but still quite restrained; the texture of the picture surface was relatively smooth; and the objects in the picture were not apparently dissolving under the impact of light as they do, for example, in Monet's paintings. Moreau defended *The Dinner Table* against its critics on straight-

THE DINNER TABLE

An ambitious painting which caused some controversy; even in 1897 it was too Impressionistic for many tastes – although it now looks conventional by comparison with Matisse's work of only a few years later.
1897. Stavros S. Niarchos Collection.

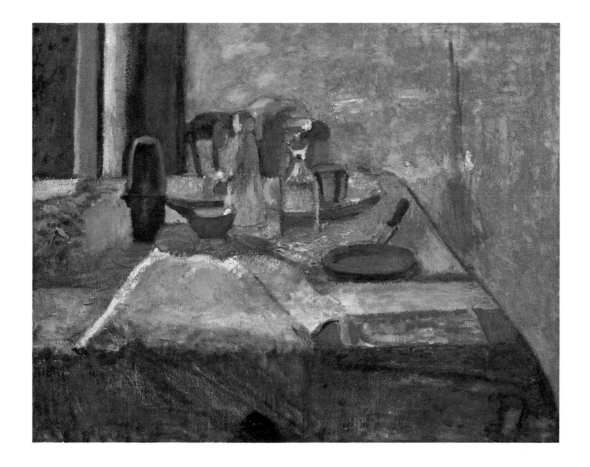

forward academic lines, asserting that the carafes in the painting had glass stoppers so solid that you could hang your hat on one. In this charming interior, Matisse in fact came closest to painters such as Pierre Bonnard and Edouard Vuillard, who had successfully adapted the open-air technique of Impressionism to a more intimate and more decorative style.

The Impressionist influence on Matisse became more apparent in the seascapes he painted during the summer of 1897 at Belle-Ile, and by the end of the year he apparently found himself in a state of crisis – perhaps uncertain how to reconcile his new discoveries with the demands of a career. At any rate, he decided to take a year off from the round of studio and salon. In January

STILL LIFE AGAINST THE LIGHT

This was done during a period when Matisse was producing still lifes in greens, oranges and purples.
1899. Private collection.

1898 he married and, after a honeymoon in London – where he followed Pissarro's advice and studied Turner's paintings – he spent a year in the South, at first in Corsica and later near his wife's native Toulouse. On his return he found that Moreau had died, and had been replaced at the Beaux-Arts by Fernand Cormon, a painter of huge pseudo-historical canvases who could see nothing in Matisse's work; he soon ejected Matisse from his class on the grounds that he was too old to carry on as a student.

During this period, and for some years to come, Matisse felt the need to work in a regular teaching studio – less, it seems, for the instruction on offer than for the companionship and stimulus provided by his fellow-students. Having been cast out by Cormon, he returned briefly to the Académie Julian, but found he no longer fitted in there; even the other students treated his work as a joke. A more congenial atmosphere prevailed at the studio of Eugène Carrière: the master left him to work on his own, and he made a number of friends including two more future Fauves, André Derain and Jean Puy. When Carrière's studio closed, Matisse and his friends worked at the private studio rented by one of their number, Jean Piette, clubbing together in order to afford the hire of a model. Matisse seems already to have acquired a certain authority among his friends

from Moreau's and Carrière's, based partly on his seniority and partly on his persistence and capacity for work, which rapidly became legendary.

This authority is all the more impressive in that Matisse himself still lacked a clear sense of direction. During his 'year off' he had revelled in his new-found freedom as a colourist, painting landscapes and still lifes of considerable boldness; on occasion, the manner in which he simplified forms and eliminated nuances suggested that he might already be feeling his way towards an art of pure colour. However, around the turn of the century he seems to have been beset by new uncertainties. His palette darkened again, but there was no return to academicism; instead, he produced a series of works – interiors, views of Paris, nude studies, his first sculpture – that are hard to characterize beyond saying that most of them tend towards a certain almost oppressive heaviness.

Matisse's uncertainty probably derived from his belated awareness of the great variety of 'modern' styles available to the artist. By 1900 there were a host of competing schools and styles – Impressionist, Pointillist, expressionistic in the manner of Van Gogh, decorative in the manner of Gauguin, Symbolist and so on – which made it harder than ever before for an artist to find himself; Matisse was by no means the only one to

INTERIOR WITH HARMONIUM

Like many of Matisse's interiors, this might equally well be called a large-scale
still life. The technique of 'tilting' the composition towards the spectator,
sacrificing literal accuracy in the interests of impact, derives from the practice of
Matisse's great French predecessor, Paul Cézanne.
c. 1900. Musée Matisse, Nice-Cimiez.

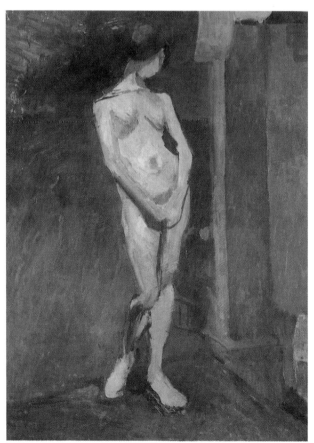

try out a variety of styles, and many of his less fortunate contemporaries never arrived at anything more substantial than a feebly eclectic manner. For Matisse, perhaps anxiously aware of himself as a late-comer, still striving to catch up with his contemporaries while lacking their facility, the period must have been an exceptionally difficult one. The evidence of his anxiety is negative – only the fact that, in his published statements, he had little to say about his development, preferring to imply that his struggles were over once he had discovered 'rainbow colours' (in 1896), and that thereafter he travelled a straight and easy road to Fauvism and beyond.

Perhaps the most important of the influences Matisse sought to absorb was that of Paul Cézanne. In the 1870s Cézanne had been an Impressionist, but the Impressionists' concern with the transient effects of light and atmosphere never really satisfied him. Working in the South, near his native Aix, or by himself in the rural environs of Paris, he had gradually developed a still more radical and original art which remained virtually unknown until the 1890s; when Pissarro praised him to Matisse, Cézanne was just begin-

ning to acquire a few young admirers among the artistic avant-garde. Cézannes' work was a revelation to Matisse, who in 1898 managed to buy the master's *Three Bathers*, a painting which served him as a kind of artistic touchstone for almost forty years (in 1936 he presented it with due solemnity to the Musée du Petit Palais in Paris). Cézanne's example was inspiring on both a personal and an artistic level. He had endured years of neglect, approaching his work with a high seriousness not found among academic careerists; and he was prepared to paint the same picture – at any rate the same subject, such as bathers in the open air – again and again. The significant aspect of this, from Matisse's point of view, was that Cézanne was more concerned with the development of his art – with an arrangement of colours on a two-dimensional surface – than with fidelity to the appearance of things outside the world of his canvas, or with 'variety' in the subject or anecdotal sense. As we have seen, the concept implicit in such works – the concept of autonomy – was of decisive importance not only to Matisse but to the entire history of 20th-century art. Matisse owed this and much else to Cézanne;

Opposite above

STILL LIFE WITH ORANGES

The influence of Cézanne is strongly felt here.
c. 1902. Washington University Art Gallery, St. Louis, Missouri.

Opposite below

NUDE STUDY IN BLUE

Done during Matisse's 'pre-Fauvist' period, it indicates his preference for cobalt blues at this time.
c. 1899–1900. Tate Gallery, London.

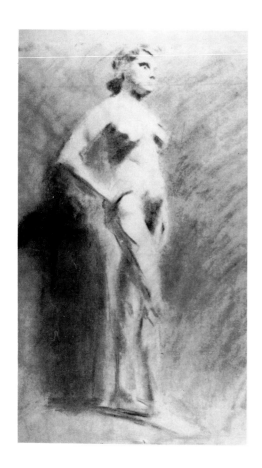 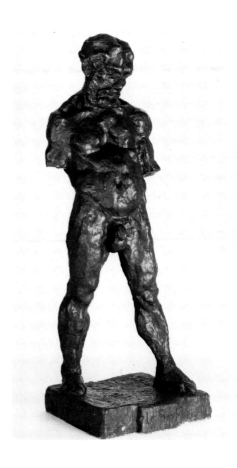

Above left

CHARCOAL STUDY OF A FEMALE NUDE

This was done when Matisse was undecided between a variety of styles.
c. 1899–1901. Musée de Grenoble.

Above centre

NUDE STUDY IN BLACK CHALK

Belongs to around the same period as the charcoal study.
c. 1899–1901. Musée de Grenoble.

Above right

THE SLAVE

Matisse began experimenting with bronze sculpture in 1899. This figure,
although influenced by Auguste Rodin, is the best of his early efforts.
1900–03. The Baltimore Museum of Art, Cone Collection.

however, it is also possible that some of his difficulties in 1900–3 resulted from his attempts to match Cézanne's preoccupation with firm structures and monumental form, which were never to be the strongest elements in Matisse's work. This influence seems most notably present in such works as *Corner of a Studio* (c. 1900), *The Coiffure* (1901) and in the various studies he made of a singularly brutish male model who is also the subject of Matisse's sculpture *The Slave* (1903).

The *Three Bathers* meant so much to Matisse that he refused to sell the picture even when he and his family were very hard pressed for money. As luck would have it, his period of artistic uncertainty was also one of financial difficulties, during which it became impossible for him to support a wife and three small children. Marquet was equally poverty-stricken, and for some months in 1900 the two men took on any jobs they could get as decorators; for a time they were employed to gild mouldings in the Grand Palais, the great exhibition hall being built for the Universal Exposition of 1900. The job was not a great economic success, since the damp and dust of the construction work gave Matisse bronchitis, and in the following year his father took him on a trip to Switzerland to cure it. Despite his concern, Emile Matisse seems to have despaired of his son's artistic career at about this time, for he cut off Matisse's allowance, making his economic problems still worse. Madame Matisse helped as best she could, opening a millinery shop in the Rue de Châteaudun, but his sons had to be sent to live with relatives, and for two years matters became so desperate that the whole family had to spend the winters in the parental home at Bohain. Matisse's schemes to raise money came to nothing: he started to paint pot-boilers but simply couldn't manage it, and he tried without success to recruit a circle of patrons who would guarantee him an income in return for work.

Despite all his difficulties, Matisse kept on working and studying (he remained an indefatigable attender of studios and classes); and among the avant-garde he gradually began to make the kind of name for himself that he had possessed several years earlier in the world of academic painting. In February 1902 the little Parisian gallery owned by Berthe Weill showed paintings by Matisse and five other pupils of Moreau; Druet, the Pointillists' dealer, took an interest in him; and in June 1904 Ambroise Vollard – Cézanne's dealer, and perhaps the most important member of the profession over the last century – gave Matisse his first one-man show. No longer welcome at the Salon de la Nationale, Matisse exhibited from 1901 at the Salon des Indépendants, which was open to all comers, and from 1903 at a new annual event, the Salon d'Automne.

Sales remained sporadic and prices quite low. Matisse's financial and artistic uncertainty persisted into 1903, when he produced paintings as varied in style as the drably realistic nude *Carmelina* and the relatively colourful *Guitarist*, in which a seated Spaniard in a kind of bullfighting uniform plays a guitar against a flower-embroidered curtain-backdrop. The model for the Spaniard was Madame Matisse, and the painter himself described the tension that built up between them during at least one of the sittings. Growing tired as a result of holding her difficult pose, Madame Matisse began to pluck the guitar strings. Matisse, irritated, asked her not to. A little while later she absently plucked the strings again; Matisse kicked over his easel, canvas and oil-pot in a temper; and his wife instantly threw down the guitar on to the heap. Then they both burst out laughing and the tension disappeared. No doubt money worries were partly responsible for the scene, but it is also one of several pieces of evidence that suggest the strain under which Matisse habitually worked, now and later. This

29

supports the view that his penchant for harmony and serenity was not the expression of an easy-going temperament but a protective device against excessive anxiety.

Matisse's return to a brilliantly colourful palette came about in a curious way, through the practice of Pointillism. What made his adoption of the technique curious was that he had tried it several years before, when working near Toulouse during his year off in 1898. In 1904, emerging from a long period of struggle, he was perhaps attracted by the theoretical coherence of the Pointillist standpoint. Pointillism was essentially a development of Impressionism; indeed, Neo-Impressionism or Divisionism are more proper if less popular labels for the movement, since the use of the *pointille* or little dot was only a single (and not invariable) aspect of the technique involved. The open-air paintings of the Impressionists had emphasized the way in which the play of strong light broke up the uniform ('local') colour of surfaces into a shimmering web of reflected colours. To capture this effect, the Impressionists had abandoned the carefully graduated tonal painting of the past, and built up their pictures with small brush-strokes of pure colour which the eye automatically blended when a canvas was viewed from a short distance away. As Matisse had noticed in his friend Wéry's work, this 'optical mixing' of pure colours gave Impressionist paintings their delightful freshness and luminous quality. In the 1880s the young painter Georges Seurat determined to improve upon

Impressionism by making a careful study of prevailing scientific theories of colour complementarity and applying them through the medium of a uniform 'dot' brush-work. The application of sophisticated colour theory and meticulous 'dotting' made a Pointillist painting extremely laborious to execute, and a good many artists – including Pissarro and Van Gogh – employed the technique for a time but ultimately found it too inimical to their freedom and capacity for instinctive response. Its pioneer, Seurat, also proved to be its greatest exponent, but he died young after producing such masterpieces as *Sunday Afternoon on the Grande Jatte* and *Bathers at Asnières*, which are Impressionist in subject-matter but quite different – grave and still and monumental – in mood and treatment. However, Pointillism continued to be propagated by Seurat's disciples, notably Paul Signac and Henri-Edmond Cross. Signac in particular, with a private income that gave him ample leisure for painting, writing and organizing, did a great deal to make the technique a subject of continuing interest to artists.

Matisse had read with interest Signac's book, *From Delacroix to Neo-Impressionism* (1899), and got to know the artist while Signac was President of the Society of Independents with which Matisse exhibited. As a result, Matisse decided to spend the summer at Saint-Tropez (not yet a fashionable resort), where both Signac and Cross lived. These friends – and perhaps, too, a renewed experience of the brilliant South – helped to bring

CARMELINA

The rather unexciting realism of this painting exemplifies the uncertainty Matisse felt in the early 20th century before the advent of Fauvism.
1903. Museum of Fine Arts, Boston, Massachusetts.

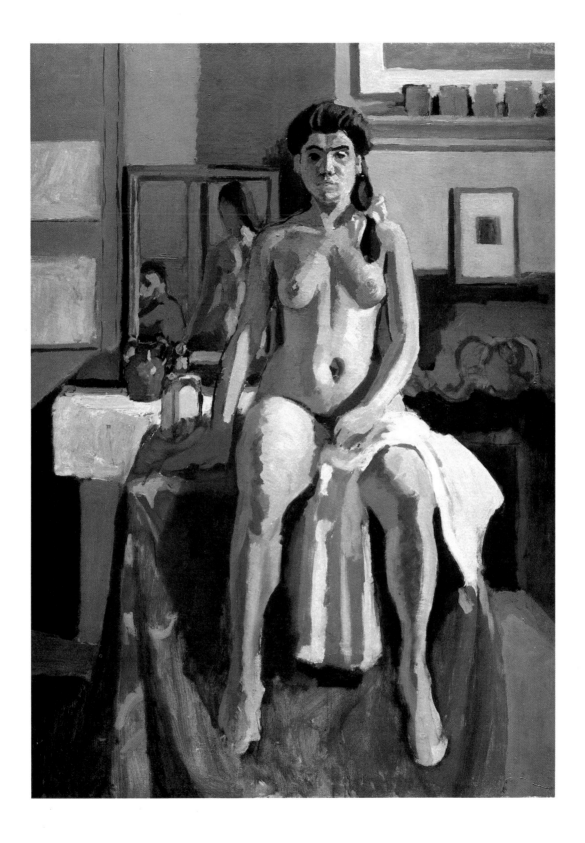

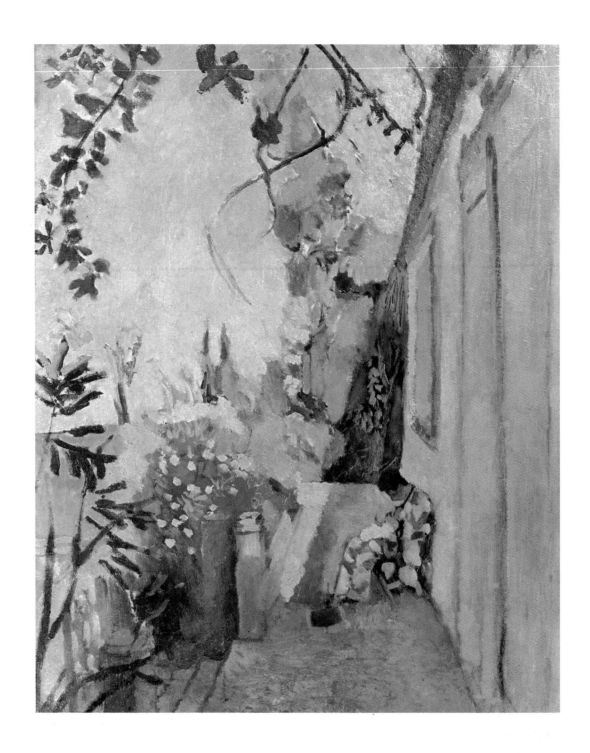

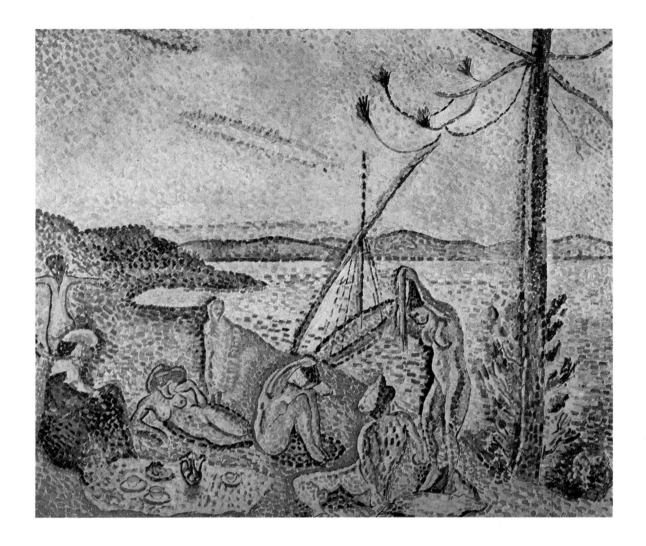

Above

LUXE, CALME ET VOLUPTÉ

*The first fruit of Matisse's short-lived conversion to Pointillism, which involves
building up a painting with small, uniform dots of colour.
1904. Musée du Louvre, Paris.*

Opposite

TERRACE AT SAINT-TROPEZ

*Painted during a summer visit to Saint-Tropez, where Matisse was in close
contact with the Pointillist artists Signac and Cross.
1904. Isabella Stewart Gardner Museum, Boston, Massachusetts.*

him alive to colour again. But, as paintings such as the *Place des Lices* and *Terrace at Saint-Tropez* demonstrate, Matisse did not go over wholeheartedly to Pointillism while he was actually in close contact with Signac and Cross; the full strength of their influence appeared after his return to Paris in the autumn – a typical example of the 'delayed-action' mechanism so often found in Matisse's artistic development. He then painted a large canvas in Pointillist style, *Luxe, Calme et Volupté*, based on studies he had made at Saint-Tropez. The title is taken from two lines of 'L'Invitation au Voyage', a poem by Baudelaire; the lines speak of order and beauty as well as luxury, tranquillity and pleasure, describing precisely the ideal world so dear to Matisse. In the painting, naked women bathers lounge about or dry their hair beside a shore; the modernity of the scene is established by the presence of tea-things laid out on a cloth, but Matisse's intention was clearly to create a timeless idyll – an equivalent, transposed into his own mood, of a tradition of French painting that included Manet's *Déjeuner sur l'Herbe* and Cézanne's various *Bathers*.

Signac, delighted to have converted Matisse, bought *Luxe, Calme et Volupté* when it was shown at the Salon des Indépendants in the spring of 1905. Ironically, although Matisse was not yet done with Pointillism, he was already becoming conscious that it did not really suit him; in later years he claimed to have been ill at ease even during his summer with Signac and Cross, whom he was sometimes inclined to dismiss as 'provincial aunts', fussing and fiddling with their dots. As Matisse saw it, Pointillism attempted to minimize the role of instinct in painting, suppressed the free-flowing brush-stroke, and created a vibrant picture surface that he found 'jumpy' – an unsettling element, lacking the kind of bold strength of colour to which he had begun to be drawn. Pointillist theory held that every dab of colour a painter used should be accompanied by its complement, whose proximity would serve to strengthen the dominant colour. But Matisse's instinct was to make every part of his painting strong, and his complements tended to be no weaker than his dominants. Observing this, Cross had predicted that he would not remain long in the Pointillist camp.

Cross was very soon to be proved quite accurate in his prediction. That summer of 1905 witnessed the birth of Fauvism.

WOMAN WITH A PARASOL

One of Matisse's Pointillist pictures. Characteristically, Matisse worked in a rather larger, looser style than other 'dotters'.
1905. Musée Matisse, Nice-Cimiez.

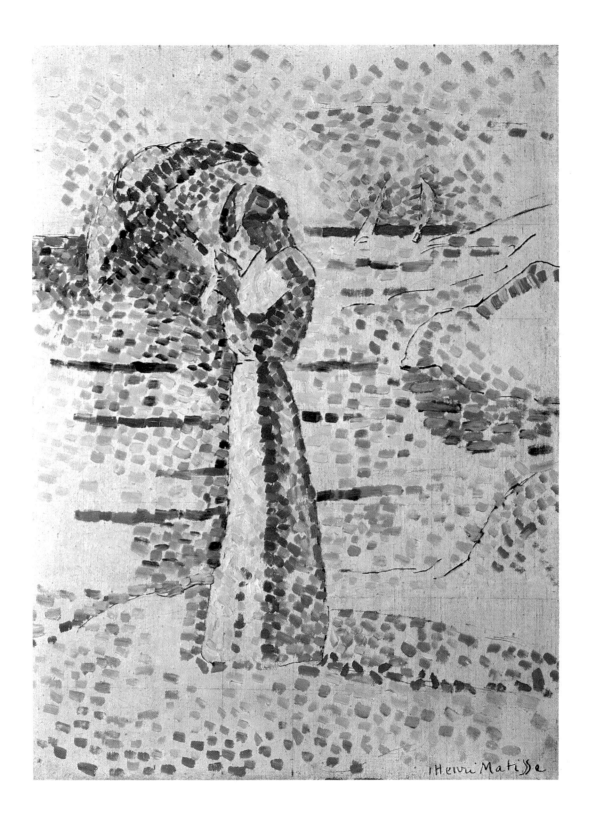

FAUVISM
AND
FAME

By 1905, Matisse and those of his painter-friends who were to be labelled 'Fauves' had formed a loose group and tended to exhibit together. At the Salon des Indépendants held in March and April 1905, they were present in force: Matisse, Marquet, Manguin, Puy, Camoin, Dufy, Derain, Othon Friesz, Maurice Vlaminck. Apart from Matisse himself, the most important artist from the point of view of Fauvism was André Derain, a young man of considerable intellect and bohemian habits whom Matisse had met in Carrière's studio in 1899. In 1901 Derain introduced him to his close friend Maurice Vlaminck, who was also to be a major figure in Fauvism. Vlaminck was an original – a former racing cyclist, a writer and musician of some ability, and a self-taught artist who loudly proclaimed that he had never visited the Louvre, and never would; when he met Matisse, he was already a bold colourist whose work expressed – and partly sublimated – the violent elements in his personality.

As might be guessed from everything we know about him, the sober, steadily industrious Matisse never really cared for Vlaminck, who remained a rather wilfully isolated figure in the Parisian art world. Derain might have had more influence, but in 1901 he was called up for three years' military service, and by the time he returned to Paris, Matisse was discarding earth colours for a second time and rediscovering colour on his own account. However, the two men quickly became friendly again, and Matisse was able to perform an important service for Derain. The younger man's parents were opposed to his adoption of an artistic career, so Derain asked Matisse to help him change their minds. Matisse – bearded, bespectacled and obviously no bohemian – visited the Derains, bringing with him his extremely presentable wife, and succeeded in convincing them that painting might, after all, be a perfectly respectable career.

When, shortly afterwards, the Salon des Indépendants closed, Derain and Matisse left Paris to spend the summer at Collioure, a little fishing village on the south coast, not far from the border with Spain; Madame Matisse had discovered it the previous year, and the Matisses were to stay there often in the years before the First World War. Initially both Matisse and Derain worked in the Pointillist style, although with a certain largeness and looseness that might not have pleased Signac. Matisse, always cautious, changed direction later in the summer than Derain; but when he did so, he not only regained freedom of brush-work (sometimes long arabesque-like strips, sometimes blobs and loose rectangles as if parodying Pointillist technique) but also began to revel in a revolutionary arbitrariness of colour. He may have been encouraged by a visit he made to Gauguin's friend, Daniel de Montfried, whose collection of that master's South Sea pictures demonstrated that colour could be used non-realistically without the connotations of emotional violence found, for example, in Van Gogh's painting.

But Matisse's employment of colour went far beyond anything attempted by the Post-Impressionist generation. In the *Landscape at Collioure* now in Copenhagen, the colours of trees and foliage include plenty of blue and red; the wall

LANDSCAPE AT COLLIOURE

Matisse used this as a study for his famous Bonheur de Vivre.
1905. Statens Museum for Kunst, Copenhagen.

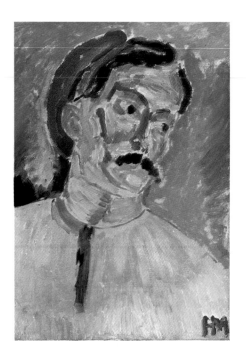 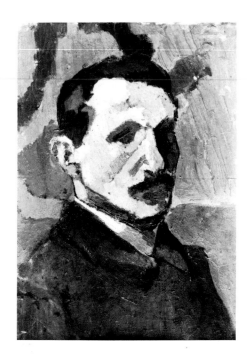

Above left

PORTRAIT OF ANDRE DERAIN

*Another example of Matisse's work during his Fauvist period, painted at
Collioure in the summer of 1905.
1905. Tate Gallery, London.*

Above centre

PORTRAIT OF MATISSE

André Derain

*Derain was a bold colourist and became a leading member of the Fauves.
Although younger than Matisse, he eventually turned his back on modernism,
painting exclusively in traditional style.
1905. Tate Gallery, London.*

Above right

PORTRAIT OF ALBERT MARQUET

*Marquet became Matisse's close friend when the two men were students at
Gustave Moreau's studio. Marquet shared many of Matisse's hardships, and
was associated with him in the Fauve group.
c. 1905. Nasjonalgalleriet, Oslo.*

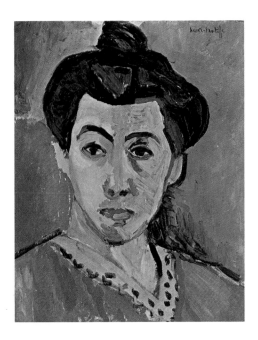

that frames the *Open Window at Collioure* is painted in three different colours; and in the famous *Women with the Hat* (Madame Matisse), painted in the autumn following Matisse's return from Collioure, the looking-over-a-shoulder pose and the model's huge and elaborate hat would stamp the picture as a conventionally fashionable portrait – were it not for the woman's green face and the other 'rainbow colours' with which the canvas is executed. Another portrait of Madame Matisse, painted a little later still in 1905, has become known as *The Green Stripe* because of the strip of green that runs vertically down her forehead and nose to meet her lips, dividing her face into pink and ochre (shadowed?) areas.

There certainly seems to have been an element of provocation in Matisse's colour schemes (though he never admitted it), since the prominence given to red and green for human subjects, and to red and blue in landscapes, amounted to a positive declaration against naturalism. The 'arbitrariness' of the colours concerns their relationship to external reality not their relationship to one another: this was a vital matter, and Matisse described how the choice of two colours committed him to the selection of a third that would harmonize them – and so on. For the Fauve Matisse, then, a painting had become an arrangement of colours and shapes on a flat surface – an essentially modern attitude to a work of art.

THE GREEN STRIPE

Matisse at his most provocatively Fauve: a portrait of Madame Matisse that became notorious because of the vertical green line running from her forehead to her lips.
1905. Statens Museum for Kunst, Copenhagen.

THE FAUVE SCANDAL

Fauvism burst upon the public consciousness at the Salon d'Automne in October 1905. Matisse's exhibits included *Open Window at Collioure* and *Women with the Hat*, and most of his friends also submitted works showing a new vigour and audacity in their deployment of colour. Whether or not the artists were aware of the fact, they seemed to outsiders to be a group of dangerous radicals, in full agreement with Derain's slogan: 'Colour for colour's sake!' Their works were hung together in the central gallery of the Salon, which became known as *le cage des fauves* – the cage of wild beasts. There are conflicting accounts of how and when the word 'Fauve' was first used – not, of course, that it matters a great deal. The best story is the traditional one – that in the gallery the critic Louis Vauxcelles noticed a conventional pseudo-Renaissance statuette surrounded on all sides by wildly colourful paintings, which prompted him to remark: '*Ah, Donatello au milieu des fauves*' 'Donatello among the wild beasts.'

Other reactions to the 'wild beasts' were less witty and sympathetic than Vauxcelles'. There was a furore in which many of the critics bandied about words such as 'insanity', 'barbarism' and 'confusion'; one of them sneered that, if these painters were in earnest, they ought to be sent back to school. Public derision was open enough to deter Matisse from making more than a single visit to the exhibition, while Madame Matisse stayed away altogether. *Woman with the Hat* attracted the most intense hostility. The president of the salon had initially attempted to exclude it from the show – supposedly for the sake of the artist's reputation – and even some of Matisse's fellow-artists twitted him about his garishly dressed model and sent him a cruel parody of the painting. There was, however, a certain amount of justice in the public's reaction: Matisse was,

correctly, identified as the chief and most gifted of the Fauves. He had become notorious, if not yet famous.

The Green Stripe, painted after the Salon d'Automne, indicated that Matisse was moving in a new direction. The composition was more compact and the colours, while still strong and bravely juxtaposed, were organized into large planes instead of the agitated scribbles and splashes of Matisse's earlier Fauve canvases. He had already begun to realize that, although he wanted to create an art of pure colour, the element of agitation was foreign to his temperament. He was not interested in violent emotional expression such as is found in Van Gogh's works, although Fauvism undoubtedly had its Expressionist side and was to influence many artists in that direction. In Gauguin's South Sea paintings, there was more of the harmony and serenity that Matisse preferred, despite their tinge of mystery and melancholy resignation, and Matisse's next major work can be seen as, among other things, a tribute to Gauguin. *Le Bonheur de Vivre* (also known as *La Joie de Vivre*, a re-titling for which its eventual owner, Albert Barnes, was responsible) represented the outcome of many studies by Matisse; the setting in particular – a clearing in the woods – was a memory of his first summer at Collioure. The scene is one of Arcadian simplicity in which naked men and women experience the joy of being alive: women lounge about in graceful poses, lovers embrace, pan-pipes are played. The only – necessary – element of energy on the figurative level is supplied by a wildly whirling circle of dancers in the far distance. The colours are brilliant and flat; the simplification of tones and drawing is radical; and the curvaceous, heavily outlined forms and arabesque-like trees create a set of interrelated rhythms that serve to unify the entire surface. The rhythms are in fact over-emphatic, very much in the style of the

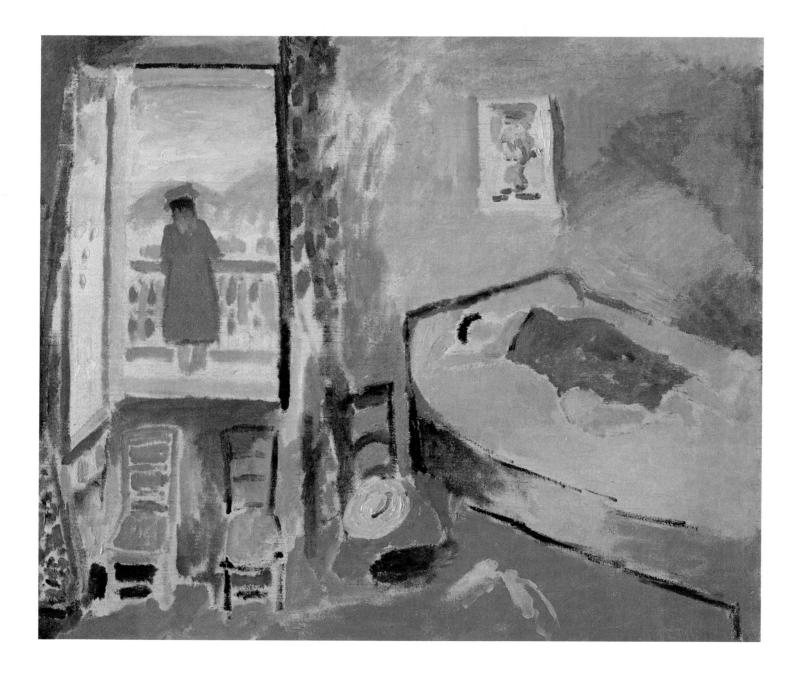

INTERIOR AT COLLIOURE

A favourite subject – the light-flooded interior with a window open on to the
world – is interpreted here in Matisse's most brilliantly daring Fauve style.
1905. Private collection, Zurich.

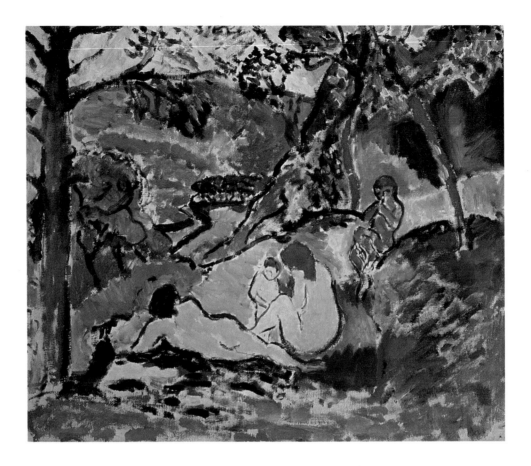

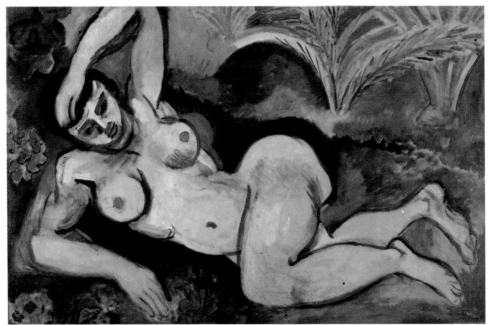

sinuous Art Nouveau line now so well known from poster reproductions, and this over-emphasis, together with a certain overall impression of slickness (an odd impression in view of the labour we know Matisse expended on the work), mutes the modern spectator's enthusiasm.

However, there are many critics who regard the *Bonheur de Vivre* as one of Matisse's major works, and whether or not they are right, it certainly ranks as a landmark in modern art. As a painting, *Bonheur de Vivre* was Matisse's vision of a happy land; but as an artifact – an object made for display – it was, given the time and place, effectively a gesture of defiance. Whereas Matisse's earlier Fauve paintings had been quite small, *Bonheur de Vivre* was monumental – a little less than 6 feet high and 8 feet wide (174 × 238 cm); it commanded the spectator's attention and compelled a response, as though Matisse was determined to insist that his audacities were not confined to cheeky sketches but were the very stuff of great art. And when the 1906 Salon des Indépendants came round, he decided to achieve maximum impact by exhibiting only the *Bonheur*. The scandalized response was predictable, and not all the hostile voices came from the 'reactionary' side. Signac, who had bought Matisse's Pointillist

Luxe, Calme et Volupté at the Indépendants the year before, was furious at this desertion; Matisse, he said, had 'gone to the dogs'. As a matter of fact, *Luxe, Calme et Volupté* and the *Bonheur* did have important elements in common: both were idylls and both were primarily works of the imagination, not transcriptions or interpretations of what the painter could see in front of him when he sat at his easel. It is interesting that, when contemplating a large-scale project, Matisse tended to draw largely on imagination and memory, yet the bulk of his output was always produced by working directly from a real model or scene, however much its appearance might be transformed in the process.

At virtually the same time as the *Bonheur* was shocking the public at the Indépendants, Matisse was being given a one-man show elsewhere in Paris, at the gallery of the dealer Druet. There were fifty-five of his canvases on offer, as well as watercolours and prints; but sales were not encouraging and the event itself was somewhat overshadowed by the controversies being aired at the Salon des Indépendants. By this time, however, Matisse had come into contact with patrons whose money and influence would do much to make him financially secure.

Opposite above

PASTORALE

An early sketch for his large composition La Joie de Vivre.
1905. Musée d'Art Moderne de la Ville de Paris.

Opposite below

THE BLUE NUDE

*One of Matisse's earliest large single nudes, it was done when he was working
on a sculpture of the same pose, and still shows Fauvist traits.
1907. The Baltimore Museum of Art, Cone Collection.*

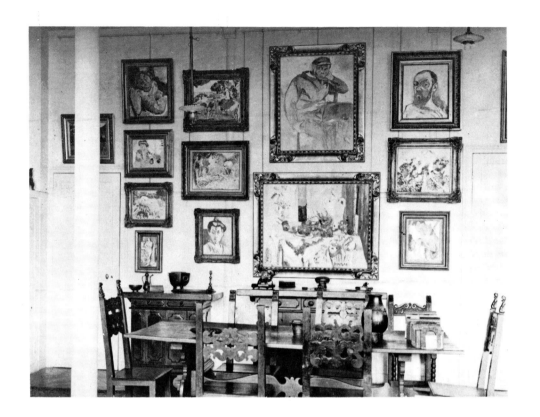

EARLY PATRONS

Until 1905 his only regular patron had been Marcel Sembat, the socialist Deputy for Montmartre. Then, at the scandalous Salon d'Automne, *Woman with the Hat* – the most scandalous painting there – had been purchased by members of the Stein family, wealthy expatriate Americans who had settled in Paris. Although there has been some confusion over the matter, the actual buyers on this occasion seem to have been the brother and sister, Leo and Gertrude Stein; soon afterwards they got to know Matisse personally, and then introduced him to their brother Michael and his wife Sarah, who became his even more ardent admirers. However, Leo made the running over the next couple of years, buying the *Bonheur de Vivre* when it was shown in 1906, and in 1907 the *Blue Nude*, Matisse's most ambitious painting of that year. Leo Stein was a type of the bohemian aesthete, right down to his corduroys and sandals, but he possessed an authentic knowledge of art and a feeling for what was new and good; as he later pointed out, at this time he was the first and

PHOTOGRAPH OF STUDIO OF LEO AND GERTRUDE STEIN IN PARIS

The American expatriates Leo and Gertrude Stein were important patrons of Matisse during his Fauve period. Gertrude Stein became a well-known 'experimental' writer.
c. 1907. The Baltimore Museum of Art, Cone Collection.

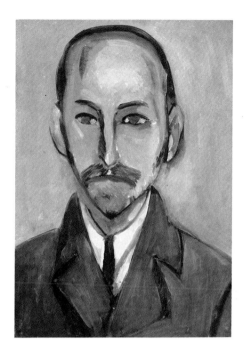

only person to recognize the existence of *both* geniuses of modern art in Paris – Matisse and Picasso. However, he was also the first of the Steins to tire of both; within a couple of years he had withdrawn his patronage, and eventually he even sold his collection.

Leo and his sister Gertrude shared an apartment in the Rue de Fleurus which became a centre for the Parisian avant-garde, and remained so after Leo's departure. Gertrude Stein was less committed to the visual arts than her brother, but she had a gift for attracting talented people; from Matisse and Picasso to Scott Fitzgerald and Ernest Hemingway, they passed through her salon and helped to make her famous. She herself was a writer whose modernism consisted of a mannered simplicity which led her to insist that 'a rose is a rose is a rose'. Like her brother Leo, she was losing interest in Matisse's work by 1907, but the

main reason seems to have been the exclusiveness of her devotion to Picasso, who had already painted his famous portrait of her; she would not be the last to feel, as Picasso put it, that he and Matisse were the North and South Poles of art. However, although they ceased to buy his works, the Steins remained friendly and hospitable towards Matisse; he, in turn, was in the habit of sending them postcards when he travelled abroad – postcards which they kept, and which later were to prove very valuable in documenting Matisse's movements.

Leo and Gertrude Stein were patrons of the first importance for a couple of years, whereas Michael and Sarah Stein bought Matisse's work steadily for more than a decade; Matisse painted portraits of each of them in 1916. He was particularly friendly with Sarah Stein, who became something close to a disciple, taking lessons

PORTRAIT OF MICHAEL STEIN

Michael Stein was the brother of Matisse's early patrons Leo and Gertrude Stein. Michael and his wife Sarah soon became even more faithful friends and patrons of the artist.
1916. San Francisco Museum of Modern Art, Sarah and Michael Stein Memorial Collection, Gift of Nathan Cummings.

from him, encouraging him to open a school, and carrying the first examples of his work across the Atlantic. Thanks to her enthusiasm Matisse acquired new American patrons, notably Harriet Lane Levy of San Francisco and the sisters Etta and Claribel Cone who, like the Steins, came from Baltimore; their outstanding Matisse collections can now be viewed in the art museums of their respective native cities. The effect of all this must have been considerable, on both Matisse's finances and his morale.

In March 1906, Matisse paid a brief visit to Biskra in Algeria before going on to Collioure, where he spent the spring and summer. The best-known of his paintings from this period is the *Self-Portrait* (Statens Museum for Kunst, Copenhagen), which shows him, without his spectacles, as a sturdy bearded man in a horizontally striped T-shirt. The conflicting tendencies already pre-

sent in Matisse's work can be seen when, for example, the highly decorative *Red Rug* in the museum at Grenoble is compared with another still life, the Copenhagen *Pink Onions*. The *Red Rug* has a sense of depth, albeit conveyed by the vertiginous tilting-forward of the pictured objects in a manner pioneered by Cézanne; *Pink Onions* consists of a few simple items, painted flatly without detail or sense of depth, and negatively outlined by a rim of canvas left unpainted around each object to separate it from its surroundings. Matisse was so uncertain of its value that he showed it to his friend Jean Puy as a curiosity, which he claimed had been painted by his postman; but Puy instantly told Matisse that he was lying and had undoubtedly executed the picture himself! An even better-known example of Matisse's experiments with simplification is *The Young Sailor*, of which two versions exist; the

THE RED RUG

One of Matisse's impulses was towards sumptuous decoration, which led him in one direction; but his urge towards clarity and the elimination of detail proved to be equally powerful. In this period he alternated quite rapidly between the two. 1906. Musée de Grenoble.

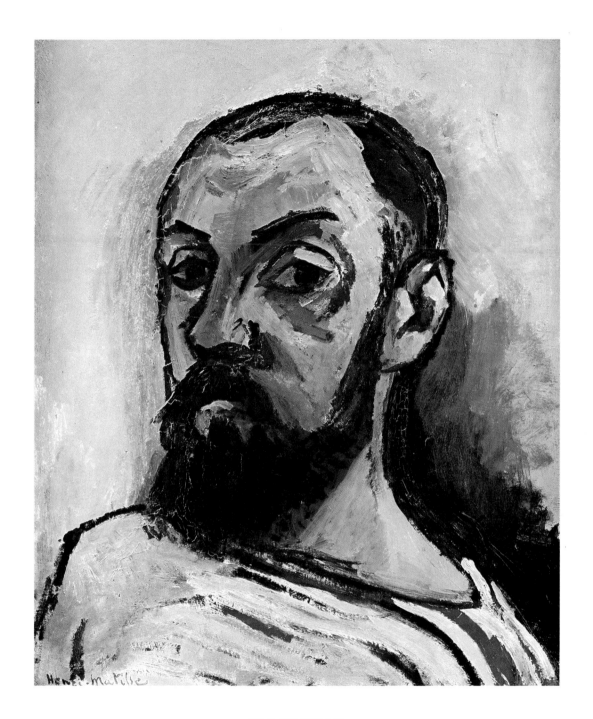

SELF-PORTRAIT

*An unusually aggressive-seeming self-portrait of Matisse, as if asserting his
identity as a fauve or 'wild beast'. It recalls self-portraits by Cézanne and was
executed during a period of wide-ranging experimentation in the years 1906–7.
1906. Statens Museum for Kunst, Copenhagen.*

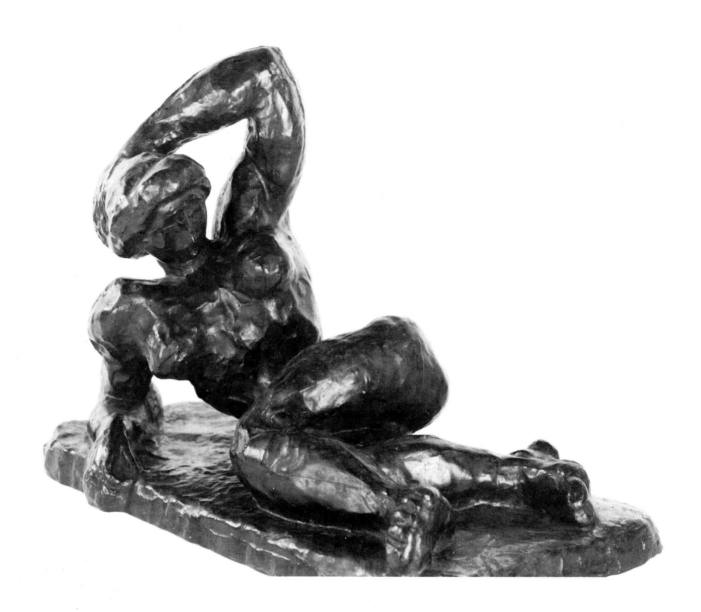

RECLINING FIGURE 1

The pose of this bronze figure became one of Matisse's obsessive subjects; he returned to it several times over the years in both paintings and sculptures. 1907. The Baltimore Museum of Art, Cone Collection.

earlier is in a muted Fauve style but with considerable emphasis on the solidity of the figure, whereas the later is flatter and brighter, abandoning the last vestiges of realistic human likeness in the interests of a rhythmic decorative effect.

Volume versus flat patterning, decorative density versus simplification – such contradictory impulses emerged in each phase of Matisse's work. During 1907 an emphasis on the monumental recurred strongly with *Blue Nude – Memory of Biskra*, in which a life-size Fauve nude is stretched out among multi-coloured palms. Few figures in Matisse's painting are as assertively solid and powerful. She lies on her side with one leg bent and brought forward to raise her haunches; one bent arm on the ground supports and raises her torso, while her other hand rests on the top of her head so that her elbow points vertically upwards. This pose had appeared before in Matisse's painting, and indeed seems to have obsessed him. The immediate impulse for the *Blue Nude* appears to have been the spoiling of an identically posed *Reclining Nude* he had been modelling to cast in bronze; later in 1907, Matisse none the less modelled a second version (one of his most admired sculptures); and after this the pose remained so significant to him that he reproduced it on a number of occasions, in several of his paintings and even on a ceramic tile.

The stress on monumentality in some of Matisse's work of 1906–7 reflects the renewed influence of Cézanne, who had just died; his art was only now being experienced and understood by many of the Parisian avant-garde, including Pablo Picasso, and that fact no doubt prompted some new reflections on Matisse's part. Matisse was also affected by contact with Picasso himself, whom he met at the Steins' apartment in the Rue de Fleurus during the autumn of 1906. Although the two men never became intimates, each gave the other one of his own works – a traditional gesture of goodwill – and 'North Pole' and 'South Pole' remained on friendly terms even after Picasso's fame had begun to eclipse Matisse's. Not long after their first meeting, Matisse introduced Picasso to African sculpture – an important service, for this art was a powerful influence on Picasso's famous *Demoiselles d'Avignon* of 1907, which set him on the path to Cubism. A painting such as Matisse's *Woman Standing* (1907) suggests a reciprocal influence: the sharply angled shoulder-blades and buttocks, and the hint of faceting in the body's surfaces could well owe something to Picasso's proto-Cubism.

However, Matisse made no attempt to follow Picasso and Braque – a one-time Fauve – into Cubism proper, in which reality was dismantled and reassembled in faceted and geometricized forms. The main thrust of Matisse's painting proved to be towards simplification and decoration, and after returning from a summer trip to Italy he exhibited *Le Luxe I* and *Music (sketch)* at the 1907 Salon d'Automne. *Le Luxe I*, a large painting with over-life-size figures, was already boldly simplified in drawing and colour, but its audacity in this respect was soon to be surpassed by *Le Luxe II*, finished in late 1907 or early 1908; this painting, with its mild, flat colours and simply outlined forms, represented a definite break with Fauvism in favour of decorative harmony. The smaller *Music (sketch)*, showing a nude group of children in which a boy plays the violin, is of special interest since it provided the inspiration for two of Matisse's most important large decorations, *Music* and *The Dance*, which will be discussed later. The word 'sketch' (*esquisse*) in the title of the 1907 *Music* was Matisse's own, which he also, for a time, applied to *Luxe I*; unless the modesty of the word was intended to ward off criticism of the way in which detail had been eliminated in the paintings, it is hard to imagine why Matisse used it.

Above left

NUDE ON A BEACH

*The landscape is more prominent than in other pictures painted about this time
but remains austere.*
c. 1908–9. Private collection.

Above right

LE LUXE II

*The decorative harmony of this painting indicated that Matisse had definitely
abandoned Fauvism.*
1907–8. Statens Museum for Kunst, Copenhagen.

AN INTERNATIONAL AUDIENCE

The period that followed was, from Matisse's point of view, a paradoxical one. By 1908 he was losing his position as chief of the Parisian avant-garde; Fauvism was *passé*, and Picasso and Cubism had come to represent everything that was new and exciting in art. Yet at this very time, Matisse's works began to find an international audience, while he himself widened his activities to include teaching and writing.

True, the international audience displayed mixed reactions to his work; outside France he was still 'king of the wild beasts', and something of the first shock of Fauvism was experienced again and again during 1908 – in the United States, Britain, Russia and Germany. Matisse's first one-man show outside Paris was arranged by the famous American photographer Edward Steichen, and took place at '291', Alfred Stieglitz's gallery on New York's Fifth Avenue. The exhibits were not Matisse's oil paintings, but a collection of watercolours, drawings, lithographs and etchings. (Lithography and etching are techniques for making multiple prints. Etching gives effects of great delicacy but is a laborious process that entails 'drawing' in acid on a metal plate, which is inked and wiped over so that only the bitten-away design prints when the plate is pressed on to paper. In lithography – most widely familiar as a poster-printing technique – larger effects are possible, since there is no relief-work involved; impressions are taken from a flat stone on to which the artist has either drawn directly in chalk or transferred an independently executed drawing; Matisse often used the transfer lithograph technique for his simpler line drawings.) Americans were not therefore confronted with Matisse's most daring work as a colourist, although even the watercolours (a medium in which 'sketchy' and simplified effects were rela-

tively acceptable) raised a few eyebrows. The New York critics were more worried by the 'ugliness' of Matisse's work and, in particular, of his female figures, which was felt to be a moral rather than an artistic fault; the same complaint had, of course, been made by both critics and public in a number of countries since at least the 1860s, whenever painters departed from the academic norm of 'chocolate-box' pretty features and perfect proportions that represented the Victorian ideal of romantic but innocuous womanhood. Despite such reservations, the more perceptive American critics acknowledged Matisse's power and skill as a draughtsman, and the exhibition could be regarded as a success by its organizers, who were encouraged to repeat the experiment in 1910.

Matisse's reception in the United States would certainly have been sharper if his paintings had been on display, as is apparent from the reaction of a conventional American critic who did see them. The Paris correspondent of *The Nation* went to the Salon d'Automne of October 1908 and was outraged: some of the works on display, he told his readers at home, were 'direct insults to eyes and understanding', While Henri Matisse was singled out as an artist – and, by implication, as a confidence-trickster – who had forgotten that not all spectators were fools, and who wilfully tried to be different from everybody else. Remarks of this sort had already been uttered so often by incensed orthodoxy that they had become the tiredest of clichés, as a letter to *The Nation* pointed out by amusingly claiming to trace their ancestry, and the accompanying head-shakings, all the way back to the Sumerians and ancient Egyptians. The author of the letter was no less a figure than Bernard Berenson, a world-famous expert on Italian Renaissance painting who still looms large in the record of art history and criticism; indeed, *The Nation's* anonymous reviewer merits notice only because of Berenson's

response to him. Berenson placed himself firmly in the ranks of the 'fools' who admired Matisse; so far from trying to be different, wrote Berenson, Matisse had discovered the great high road travelled by all the masters of the previous sixty centuries, and resembled them in all essentials. He was 'a magnificent draughtsman and a great designer'. Berenson praised Matisse's colour too, although a little more guardedly: he could understand its failing to charm, since 'we Europeans [sic]' were uncertain about it and easily frightened by any divergence from the norm. Unaware of the existence of the Steins and Matisse's other American patrons, Berenson ended his letter by lamenting that Americans were no longer pioneers in the appreciation of great modern art. Given the immense authority of Bernard Berenson among scholars and critics, his protest to *The Nation* must rank as the most powerful defence of Matisse to have been made up to that time.

Matisse's British debut was more modest: the exhibition of a canvas at the New Gallery in London, as part of a show held by the International Society of Painters, Sculptors and Engravers. Matisse's work was noticed by a contributor to the influential *Burlington Magazine*, but he or she dismissed it, along with other exhibits, as 'infantile', a manifestation of Impressionism in its second childhood. In 1910 Matisse exhibited at Brighton ('Modern French Artists')

and at the 'Manet and the Post-Impressionists' show at the Grafton Galleries in London, which effectively introduced the British public to modern art. In spite of the championship of men like Roger Fry and Clive Bell, outstanding modernist critics who played a large part in organizing the 1910 'Post-Impressionist' show and its successor in 1912, Matisse's work made only a limited impact – not surprisingly, perhaps, with an audience that had not so long before come to terms with Impressionism and was now being urged to absorb, in a single lump as 'Post-Impressionism', several decades of radical experiments from Gauguin and Van Gogh to Picasso and Matisse.

By 1908 German collectors were showing a considerable interest in Matisse, encouraged by his ardent admirer Hans Purrmann, a young German painter who had experienced an instant conversion on seeing the *Open Window at Collioure* and *Woman with the Hat* at the 1905 Salon d'Automne. Matisse and Purrmann visited Bavaria in the summer of 1908; the trip seems to have been a light-hearted one, but in any case Munich would have seemed a sympathetic place from an artistic point of view, since it was one of the leading centres of the avant-garde in Germany. Berlin also had a strong avant-garde tradition, but it was not much in evidence in the December of 1908, when Purrmann arranged for an exhibition

STILL LIFE WITH GERANIUMS

This was the first of Matisse's works in a mature 'modern' idiom to be acquired by a museum (in 1912). It was commissioned by Hugo von Tschudi for the Neue Staatsgalerie in Munich.
1910. Staatsgalerie Moderner Kunst, Munich.

of Matisse's painting in Paul Cassirer's gallery there; the atmosphere may have been influenced by the fact that, earlier in the year, the Kaiser had dismissed the director of the Berlin National-galerie, Hugo von Tschudi, who had initiated a policy of buying modern French works. When Matisse and Purrmann went to Berlin in order to supervise the exhibition, they found the gallery owner reluctant to put it on, and critics and even fellow-artists hostile; within a few days of Matisse's hasty departure, the show had closed. Some amends were made in 1910, when von Tschudi commissioned a painting from Matisse; two years later, this work, the *Still Life with Geraniums*, became the first of Matisse's 'modern' canvases to be acquired by a museum, the Munich Neue Staatsgalerie of which von Tschudi had become director.

Russian interest in Matisse, and in modernism generally, was one of the more remarkable phenomena of the period. It has been suggested that the very backwardness of Tsarist Russia made it easier for Russians to appreciate an art that – like their own folk arts – was not intended to reproduce reality in 'photographic' fashion; the suggestion is all the more plausible in that the great Russian collectors of modern art tended to be merchants, a traditionally 'Russified' class, rather than the Westernized aristocracy and intelligentsia. An indigenous modern movement had already appeared in the 1890s with the

'World of Art' group, notably Serge Diaghilev, Alexandre Benois and Léon Bakst, who later devoted themselves to the Russian Ballet which was to burst upon western Europe as a revelation in 1909, manifesting a 'barbaric' brand of energy, colour and skill that influenced not only ballet and theatrical design but fashion and the decorative arts. Between 1906 and 1909 the most progressive force in the visual arts was the Moscow-based *Golden Fleece*, a monthly magazine edited and published by the wealthy painter Nikolay Ryabushinsky. In Moscow *The Golden Fleece* mounted two major exhibitions of Russian and French art (1908 and 1909), which provided a conspectus of modern art from Degas to Picasso that was hardly rivalled anywhere in pre-war Europe. The exhibitions also introduced Fauvism to the Russian public, and on both occasions included canvases by Matisse. Even more gratifying, perhaps, was a 1909 issue of the magazine which devoted its entire art section to Matisse, comprising an up-to-date selection of reproductions, a critical essay, and Matisse's own 'A Painter's Notes'. Here, too, *The Golden Fleece* was in advance of every other periodical in Europe, and Matisse was not to receive such extended critical attention again until after the First World War. As well as these favourable events, there were the activities of the great Russian collectors, which benefited Matisse and a great many other of his contemporaries, as we shall see.

TEACHING AND THEORY

Matisse's influence was particularly strong in Scandinavia, although, paradoxically, his work would not be publicly exhibited there for many years. This influence was exercised through his pupils, of whom an extraordinary number were Scandinavians, in particular Swedes. The 'Académie Matisse' at which they studied was the brain-child of Sarah Stein and Hans Purrmann. Both had been receiving a certain amount of instruction from Matisse, and by late 1907 they had reached the conclusion that others might benefit from his help; no doubt the two ardent disciples also calculated that the Master's reputation and influence would be strengthened by such a move. Matisse was persuaded to agree, Michael Stein guaranteed the financial security of the venture, and early in 1908 the school was opened at a former convent in the Rue de Sèvres where Matisse already rented a small studio. It was a success from the beginning, moving within a month or so to more spacious quarters (another former convent, this time on the Boulevard des Invalides) and rapidly attracting an international membership. About 120 pupils attended the school during its three years of existence; of these, a good many became prominent in the arts of their own countries, although only two painters, the American Max Weber and the Englishman Matthew Smith, were to acquire anything in the way of a wider reputation.

The conservatism of Matisse's teaching came as a shock to many of his pupils, who evidently believed that it was only necessary to 'express themselves' by flinging paint at a canvas in order to become a thoroughly modern 'wild beast'. When, at the end of the school's first week, Matisse arrived to inspect the results, he was confronted with an assortment of multi-coloured monstrosities. He left the room without a word and returned a few minutes later with a head – a cast of an ancient Greek sculpture such as any academic master might set in front of his pupils for them to copy. Which is exactly what Matisse did, pointing out to the students that they must learn to walk on the ground – to work accurately from nature – before they began to walk the tightrope!

Thereafter, the school settled into a routine: during the week the students worked on their own from a plaster cast or model, from time to time accompanying Matisse on a trip to the Louvre where he would point out the beauties of the old masters; otherwise he would put in an appearance only on a Saturday, which he spent discussing and correcting their work. 'Correction Day' tended to chasten them so thoroughly that, as Matisse remarked, they became meek as lambs on Saturday, and it took the entire week for them to become lions again. However, despite his insistence that an artist needed rigorous formal training before he could afford to break any rules, Matisse did discuss Fauve colour, distortion and similar topics, as notes taken by Sarah Stein demonstrate. Whatever the medium, the main themes of his teaching seem to have been the importance of unity in a work of art, the need to get down to essentials, and the role of the artist's emotional response to his model or subject. He praised the ancient Greeks and Romans because they gave equal attention to every part of a sculpture, whereas modern artists realized only certain parts; their works therefore lacked unity, he said, and that caused a 'troubling of the spirit' – a remark that illuminates what Matisse meant by his often-quoted preference for a serene, soothing art. At the same time, the artist should concentrate on grasping the essentials of form, which is to say, masses rather than details. Matisse even suggested that, after thoroughly studying his subject, the painter should shut his eyes and

visualize the picture in order to isolate its essentials, which he should then always keep before him (in addition to the model itself) until the work was done. Applied to a drawing, this meant that every line should justify its inclusion by having a definite function, a doctrine admirably exemplified by so many of Matisse's own works, in which everything is expressed with a maximum of economy.

Finally, there was the question of emotion. To begin with, Matisse held, the artist must put aside preconceived ideas and allow the subject to awaken an emotion in him; then he would be faced by the problem of rendering that emotion. When Matisse talks of the emotion aroused by the interrelations between the objects in a still life, it becomes clear that he means aesthetic emotions – powerful visual responses of a kind that it is hard for non-artists to experience *except* in front of a painting or sculpture in which an artist has enshrined his own responses – and not 'feelings' such as love or zest or terror. In the past, most paintings had made some appeal to such feelings, achieving part of their impact by exploiting the spectator's religious faith or horror of suffering (in a Crucifixion, for example), his sense of the pride of life (a fine horse, a soldier) and so on. Matisse was one of the earliest artists to dismiss such emotion (rightly or wrongly) as 'literary', and therefore out of place in visual art; from such

a point of view even the Expressionism of a Munch or Van Gogh ought to be condemned as 'literary', since it invites the spectator to share the painter's suffering and despair. A unity, an artistic essence, a pure distillation of aesthetic emotion: Matisse's vision of the work of art sounded noble if rather remote. However Matisse's theories were a little less clear-cut than they seemed.

In most respects, Matisse's essay 'A Painter's Notes' confirmed the message of his teaching as recorded by Sarah Stein. This essay, which appeared in *La Grande Revue* of 25 December 1908, was Matisse's first published statement, although his voice had been heard before: almost exactly a year earlier, the poet and critic Guillaume Apollinaire had quoted some of his characteristic reflections in an article written for the magazine *La Phalange*. 'A Painter's Notes' made a certain stir: Hans Purrmann translated it into German and, as we have seen, a Russian version was incorporated in the Matisse number of *The Golden Fleece*. Early in the essay, Matisse announced: 'What I am after, above all, is expression.' But he went on to explain that, for him, expression had nothing to do with passion as shown in a face, or with violent movement: the entire arrangement of his picture was expressive. To the charge that his art was limited, and offered nothing more than visual satisfaction, he replied that a painter's thought could not be separated

STILL LIFE WITH GOLDFISH

Matisse benefited greatly from the early interest shown in modern art by Russian collectors.
1911. Pushkin Museum of Fine Art, Moscow.

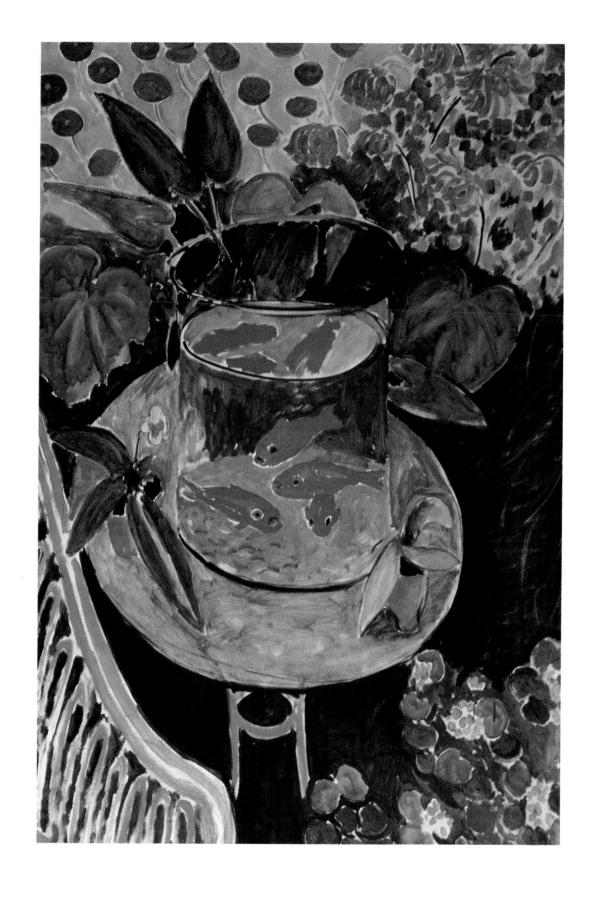

from his pictorial means, and that he could not distinguish between his feelings about life and his way of translating it into a painting. Matisse appears to be making the essentially modern assertion that the pictorial means *are* what a picture is about – that, to adapt Gertrude Stein's words, 'a picture is a picture is a picture', and not a record or evocation or emotional equivalent of something else. From this point of view, his use of terms such as 'expression' and 'the painter's thought' seems misleading (since it implies some kind of non-visual message) by contrast with his reference a few paragraphs later to a painting as a 'condensation of sensations'; in talking of 'sensations' (a favourite word of Matisse's master, Cézanne) we leave behind the verbal and moral and emotional, and find ourselves in the pure world of colour and form.

Actually Matisse, like Cézanne before him, never unequivocally took up the position that a picture had, so to speak, no obligations to the external world, whether mental or visible. At times in 'A Painter's Notes' he seems to mean precisely that; at other times he talks of using pictorial means to render 'a feeling about life', just as an Expressionist such as Van Gogh might, and he even explains his preference for painting the human figure on the grounds that it allowed him most fully to express his 'almost religious awe towards life'. Equally, his attempt to condense, and his search for the essential, may have concerned form and colour, but they were also, as he himself claimed, a way in which the image of a woman's body might be made 'more fully human'; in other words the body was not merely a source of sensations that the artist manipulated as he pleased, but also made certain claims upon him. Stranger still, Matisse asserted that an artist should believe he had copied nature – even if he hadn't; it was wrong to turn one's back on nature and work in a preconceived style. Then, as if

realizing that this was an odd statement for the painter of *Le Luxe* to make, he added that departures from nature could only be justified if the intention was to interpret it more fully by doing so. Here Matisse was obviously making a tacit rejection of charges that he just 'painted as he felt'; but his words again convey an awareness that his paintings did have a significant relationship with the world 'out there'. In some sense, the artist told 'the truth' about the aspect of nature he painted, although, Matisse was later to insist, 'exactitude is not truth'. He distinguished between unsatisfactory 'fugitive sensations', recorded in a first working session, and a 'condensation of sensations' that was somehow more representative of his state of mind, in which serenity had replaced excitement.

All this explains why Matisse never showed much interest in the Cubist dismantling of reality, and avoided abstraction until the last years of his life. In a sense, abstract art is the logical culmination of a belief in the autonomy of the artist: in abstract works form and colour, solids and voids exist entirely in their own right, without support from or appeal to any external reality. By contrast, Matisse's art retained a definite, though vestigial, link with that reality; and if his theoretical formulations were not entirely consistent (or, perhaps, language could not accommodate the distinctions he wished to make), his work was none the worse for contradictory impulses that kept it from stagnating over six decades of activity. The demands of art and the demands of reality, imagination and sensation, simplification and decoration, essence and detail – such polarities were a source of anxiety for Matisse, but also a source of creative stimulus. Given his temperamental preference for an untroubled, harmonious and pleasurable art, memorably stated in 'A Painter's Notes', a degree of creative disturbance was essential to his development.

MATISSE THE SCULPTOR

Such disturbances were apparent in the intensely fertile period between 1908 and the outbreak of war in 1914. The radical simplification of the *Le Luxe* paintings was followed up in a series of large commissioned decorative pictures, yet almost simultaneously Matisse was painting densely patterned still lifes and richly coloured interiors in a style that might almost be called naïve. His sculptures from this period are also of great interest, consisting of a body of work that is related to but not identifiable with the other categories. For Matisse, sculpture was partly a way of relaxing (the compulsive worker's 'relax-ation' being to change from one medium to another) and partly a way of tackling certain problems of form and volume that could be approached via modelling. In a sense, then, he had no independent ambitions as a sculptor, which perhaps explains his failure to develop certain highly original concepts. In the *Jeanette* series of five heads (1910–13), for example, he began in a vigorous naturalistic style and proceeded to pull the features about until, in *Jeanette V*, he produced a creature stranger than anything his Cubist contemporaries had invented; its affinities were with the women in Picasso's paintings some twenty years later. None the less, Matisse made no attempt to go further than *Jeanette*, virtually

LA SERPENTINE

The distorted forms of this lively sculpture did not at first find favour.
1909. The Baltimore Museum of Art, Gift of a Group of Friends of The Museum.

giving up sculpture for more than decade. By contrast, the haunch-high pose of the *Blue Nude* obsessed him for years. The original model was put together again and cast (*Reclining Nude I*, 1907), and Matisse featured it regularly as an item in his still-life pictures – in the Oslo *Sculpture and Persian Vase* (1908) and various 'goldfish with sculpture' paintings of 1910 to 1912 – although ringing the changes on its exact appearance and the point of view from which it was seen. In the form of the bronzes *Reclining Nude II* and *Reclining Nude III*, the pose reappears in Matisse's work as late as 1927, and there are many reminiscences of it in the famous twenty-two 'work-in-progress' photographs of the 1935 *Pink Nude*. Matisse evidently enjoyed the art-as-play element involved in placing an image of one of his works within the framework of another. The presence of a small nude sculpture in a still life was more than a piece of self-indulgent cross-referencing, however. The 'near-life' nude would enliven the still

life – and in fact, since the 'statuette' was painted with a voluptuous relish that made it seem entirely alive, these pictures acquire a curiously surrealistic charm from their apparent incongruities – that a women can be lying on a (gigantic?) table, can find herself smaller than a goldfish tank, and so on. Even when we know that the nude is supposed to be a sculpture, the effect is unchanged.

Another small bronze sculpture that can also be seen in one of Matisse's still lifes is *Two Negresses* (1908), which in the painting *Bronze and Fruit* (1910) is set among a confusion of scattered fruit and dishes against a brilliantly patterned tablecloth. In this as in other 'table-top' still lifes in the manner of Cézanne, Matisse followed 'the master of Aix' in tilting the table right forward – up against the picture surface, so to speak – in the conviction that the consequent equality of strength given to every part of the canvas was more important than the fleeting illusion of real

Opposite, top left

JEANNETTE I

These bronze heads show Matisse repeatedly attacking a single subject.
1910–13. Collection, The Museum of Modern Art, New York. Acquired
through the Lillie P. Bliss Bequest.

Opposite, top centre Opposite, top right

JEANNETTE II; JEANNETTE III

1910–13. Collection, The Museum of Modern Art, New York. Gift of Sydney
Janis.

Opposite, bottom left Opposite, bottom right

JEANNETTE IV; JEANNETTE V

1910–13. Collection, The Museum of Modern Art, New York. Acquired
through the Lillie P. Bliss Bequest.

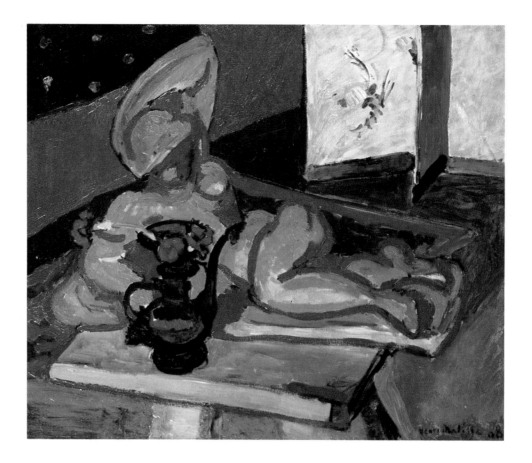

depth provided by traditional perspective. The bronze *Two Negresses* is perhaps Matisse's masterpiece as a sculpture. Small but monumental in feeling, it is one of the few instances in Matisse's work of a couple interlocked – physically by the arm each throws across the other's shoulder, emotionally by a gaze of shared intensity; for all its tender human presence, the group is tree-like in the rooted, durable strength it possesses. This was an extraordinary achievement, and especially for a painter used to translating the world into two

dimensions. The *Two Negresses* is, in fact, a work of exceptional three-dimensional impact which no photograph quite succeeds in capturing, equally strong and lucid when viewed from any angle.

Part of the monumental effect of the *Two Negresses* derives from the unobtrusive pattern of bulging calves, buttocks and breasts on the women's sturdy bodies. In order to balance his composition, Matisse took liberties with physiology, thickening the figures' legs below their knees.

BRONZE AUX OEILLETS

The bronze in this still-life painting is clearly the Reclining Figure *illustrated earlier. Matisse enjoyed this sort of play with a work-within-a-work.*
1910. Nasjonalgalleriet, Oslo.

He used this device even more audaciously in *La Serpentine* (1909), another extremely successful work. It is a little figure of a girl pensively leaning with one elbow on the top of a post; the figure is elongated, with a notably thin upper torso and thighs in sharp contrast to the thick lower legs and large feet. Even Matisse's admirers were taken aback by such distortions; one of them, Henry McBride of Philadelphia, recorded that he was struck dumb by the sight of *La Serpentine* 'whose thighs were almost as thin as wires', and was only saved from embarrassment by his companion, the English critic Roger Fry, who remained composed enough to utter what McBride took to be a few polite insincerities. During the ensuing decades, much more radical distortions became commonplace, and a work such as *La Serpentine* no longer appears bizarre or even mysterious. Without much reflection we can see that the thinness of thigh and torso is necessary to establish a rhythmic relationship between these elements and the arms, which flow in a single, large, loose s-shape across the figure; the heavier legs and feet anchor the figure and are part of a careful formal balance involving hips, head and leaning post, between which the rhythms of the 'thin wires' play. On a less technical level, we can feel a pleasurable surprise that such departures from the anatomical norm do not in fact make the girl seem any less attractive in her pensive-provocative way: the pose, and the play of rhythms, give us all the visual information we need.

Matisse's enduring preoccupation with simplification and stripping down to essentials is shown most vividly, because progressively, in *The Back*, a work (or series of works), executed over a period of twenty years, that may conveniently be discussed here. The dating of these over-life-size reliefs is only approximate, since they were not exhibited in Matisse's lifetime; indeed, the very existence of *Back II* was unknown, and the four reliefs were not shown as a series until 1956, when the Tate Gallery in London acquired a set. In *Back I* (c. 1909) the figure has been flattened, as if squashed against an imaginary surface, but it is still clearly a nude woman seen from behind, her head resting in the crook of her elbow and her weight on her left foot; her limbs are vigorously articulated, although the deep groove down her spine foreshadows the fragmentation to come. Four or five years later, when Matisse returned to the subject with *Back II* and *Back III*, he increased the size of the figure so that it filled out the panel, straightened the left leg and squared the shoulders; at the same time he introduced a long mane of hair falling down the back of the figure, converting the negative vertical (the spinal groove) into a positive element, separated from the back but running without articulation into the formalized slab of the head. In *Back IV* (c. 1930) the processes of simplification and separation have been carried to a point at which the figure consists of no more than three large, scarcely articulated shapes which do, none the less, unmistakably convey the subject-matter they represent. Such a sequence, constructed over such a long period of time, has no close parallel in the history of Western art.

Most of Matisse's sculptures were quite small; the more ambitious scale of *The Back* became possible because he moved, in the summer of 1909, to a country house just outside Paris, at Issy-les-Moulineaux, where the garden was large enough for the erection of a spacious prefabricated studio. The removal to Issy marked the beginning of Matisse's withdrawal from the Parisian hurly-burly, including its artistic politics and his own school, whose calls on his time seem to have been a source of concern to Matisse from the first; henceforth his Saturday visits became increasingly irregular, and the school itself finally closed in 1911.

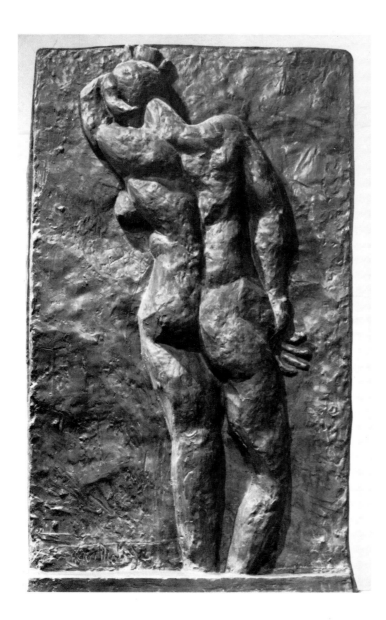

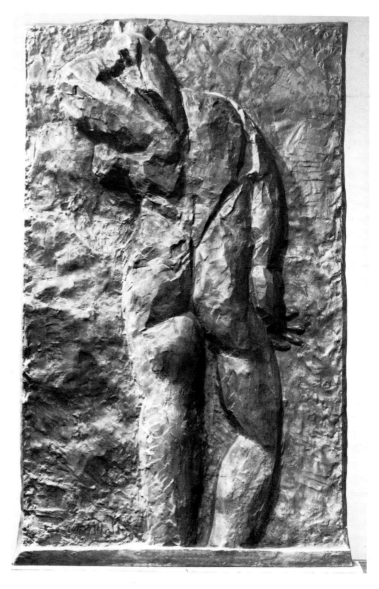

Above left

BACK I

This bronze and its three successors are over life size.
1909–10. Tate Gallery, London.

Above right

BACK II

c. 1913–14. Tate Gallery, London.

 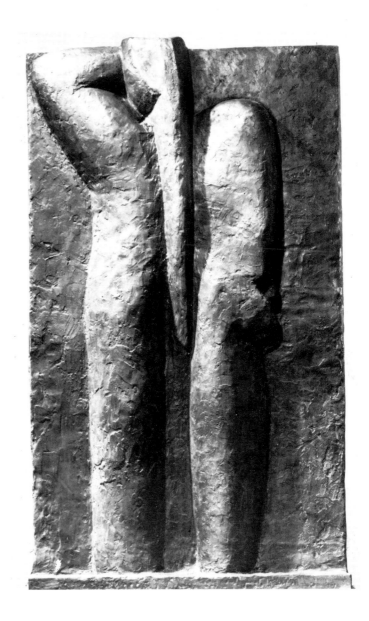

Above left

BACK III

Progressive elimination of detail culminates in near-abstraction.
c. 1916–17. Tate Gallery, London.

Above right

BACK IV

c. 1930. Tate Gallery, London.

PATRONS FROM RUSSIA

Matisse was now able to afford a fine house since he was attracting a gratifying number of wealthy buyers; and by 1909 he needed more studio space in order to undertake large-scale commissions from Sergei Ivanovich Shchukin, the most lavish of all his pre-war patrons. Shchukin was a wealthy Muscovite importer who spent several months of every year travelling in western Europe. He was a passionate and discriminating admirer of modern painting, and pictures by Gauguin, Cézanne and other still-controversial artists hung in the rooms of his ornate Moscow mansion, which was actually the former palace of the Troubetskoy princes, built in the 18th century during the reign of Catherine the Great. There is a singular fascination in the surviving photographs of the palace interior which show quantities of paintings by Matisse on the walls; even in black and white, the Matisses are unmistakably modern and incongruous in such a setting of massive chandeliers, elaborately painted ceilings, riotous plasterwork and fine old furniture with graceful curves and cabriole legs.

Shchukin seems to have acquired some of Matisse's work as early as 1904 or 1905, but it was in 1908 that he began buying in quantity. From that year, the *Still Life in Venetian Red* is a 'tilted', decorative Cézannesque piece, whereas *The Game of Bowls* constitutes another of Matisse's exercises in radical simplification. The most important and interesting of the 1908 paintings acquired by Shchukin was *Harmony in Blue*, a strongly patterned picture in which there was no attempt to render a sense of depth; the subject was traditional – an interior in which a servant is fussing over a food-laden table – but the treatment was 'naïve' and the painting was flooded with a brilliant blue that engulfed both wall and tablecloth, almost obliterating the difference between them. Matisse emphasized his decorative intentions and unified his blues by using an identical pattern of arabesque-like branches for both wallpaper and cloth. Shchukin saw the painting in Matisse's studio and bought it; but by the spring of 1909, when it arrived at his house in Moscow, it had been transformed into a *Harmony in Red*. Matisse had replaced the blues with an entirely uniform deep cherry red, and the changes of plane betweeen wall, table-top and vertically hanging tablecloth were barely indicated, so that they interfered as little as possible with the intended triumph of colour. The culmination of this technique occurs in *The Red Studio* (1911), in which the entire canvas is covered in a strong, unshaded red, and the presence of furniture is indicated only by outlines. A small number of items break the pattern of red-on-red; most of them are representations of works by Matisse himself – a ceramic plate, sculptures, *The Young Sailor* and other paintings – which stand out bright and clear against the uniform red background. Despite the lack of tonal variation, shadows, etc., a sufficient illusion of depth is conveyed by lines indicating where floor and ceiling meet, and by careful placing of the objects in the studio. The result, as Matisse intended, was a picture unified by colour, with no weak places.

The Red Studio was not one of Shchukin's purchases, but in the years before the First World War the Russian acquired an astonishing number of Matisses, including *The Conversation* (1909), *Nymph and Satyr* (1909), *The Painter's Family* (1911) and the *Portrait of Madame Matisse* (1913). He also gave Matisse his first major commission. He asked the artist to design a large decoration for the stairwell of his Moscow house, and was so delighted when Matisse produced a full-scale preliminary study, *The Dance*, that he contemplated commissioning not one but two great decorative works. On 31 March 1909, writing

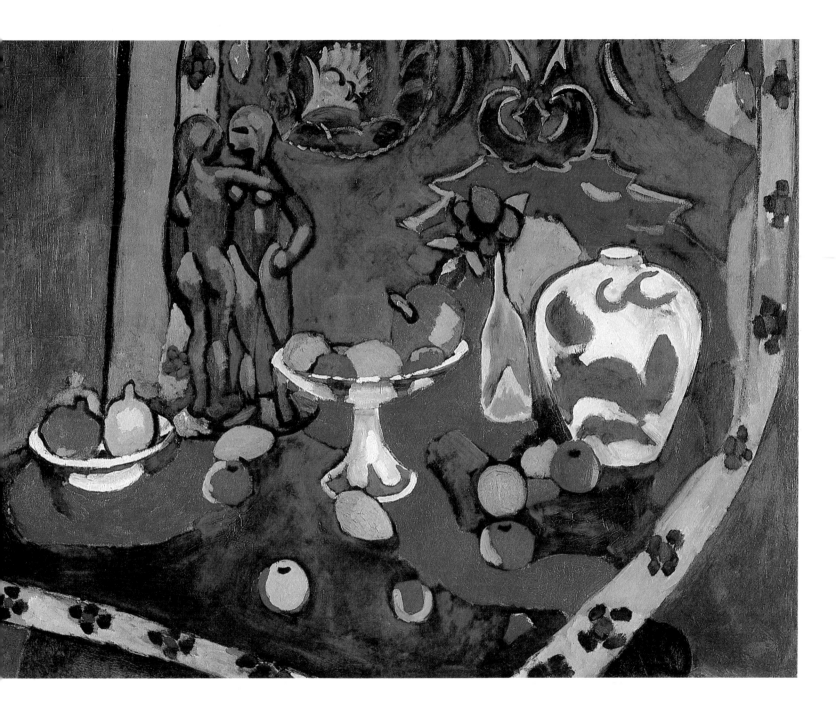

FRUIT

*Another still life which excited Russian interest and eventually passed from a
private collection into the hands of the state.
Pushkin Museum of Fine Art, Moscow.*

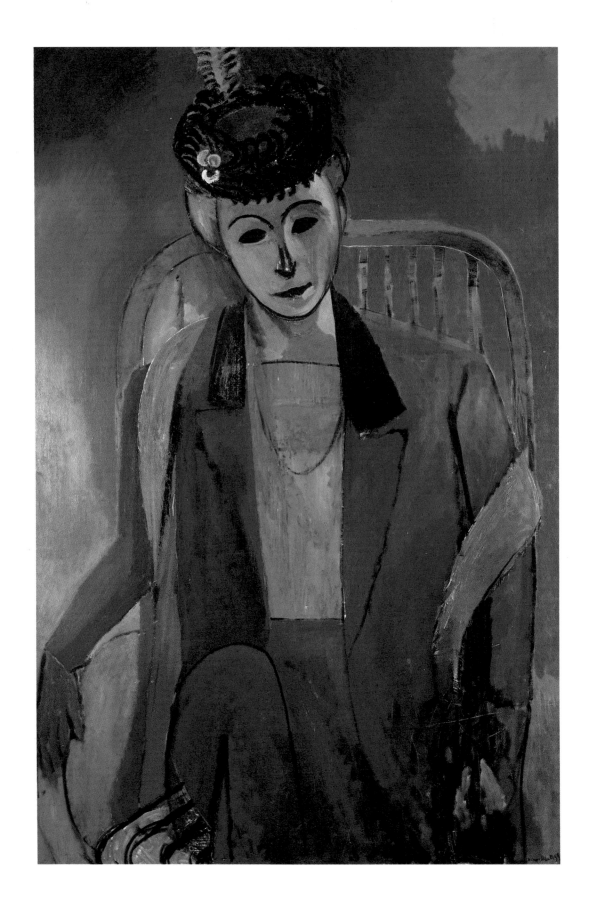

Above

PORTRAIT OF SERGEI SHCHUKIN

*A charcoal drawing of the Russian collector Shchukin, who was the most
important of all Matisse's patrons before the First World War. He commissioned
the great decorative works* The Dance *and* Music.
1912. Private collection.

Opposite

PORTRAIT OF MADAME MATISSE

*Even before the outbreak of war Matisse's work began to assume more sombre
tones and this portrait is remarkably restrained in its use of colour.
State Hermitage Museum, Leningrad.*

from Moscow, Shchukin gave Matisse a firm order for *The Dance* and *Music*, for which he would pay 15,000 and 12,000 francs respectively. As we have seen, Matisse's move to Issy-les-Moulineaux may have been partly motivated by his need for space to work on these paintings, each of which was to be almost 13 feet (just under 4 metres) long. Matisse had finished them, at the latest, by the summer of 1910.

The Dance is probably Matisse's most famous painting, and fulfills a prediction Gustave Moreau is said to have made – that his pupil was 'destined to simplify painting'. Physical detail and even the range of colours are reduced to a near-minimum in this intensely vital picture of dancers whirling in a circle. The simplification was, of course, achieved with great labour and after profound meditation; the outcome was a group in which every figure was involved in a relationship of dynamic rhythm and formal equipoise with every other figure. As for the colours, Matisse himself described them as comprising the bluest of blues for the sky, the greenest of greens for the ground, and a vibrant vermilion for the dancers' bodies, all coloured to saturation. On occasion Matisse was shocked by his own colours when, forgetting it was there, he unexpectedly came upon the painting in his studio. And the electric vibration it seemed to give off at twilight appears to have induced a kind of superstitious awe in Matisse, who invited the photographer Edward Steichen to his studio in order to be assured that there were sound scientific reasons for the phenomenon.

The Dance probably originated in Matisse's memories of folk dancing and in the group that appeared in his own *Bonheur de Vivre*. On one occasion he claimed to have been directly inspired by recollections of a vigorous group dance called the farandole, which he had seen at a Parisian dance-hall, the Moulin de la Galette. When he received Shchukin's commission, Matisse recalled, he went back to watch the dance again, then started work on his canvas, singing the tune he had just heard at the Moulin de la Galette.

Music was suggested by the *Music (sketch)* of 1907; in particular, Matisse took over the standing fiddler from the earlier picture, and developed the seated figure in the 'sketch' into an audience of three; but he entirely dispensed with the dancing couple who appear in *Music (sketch)*. In the painting for Shchukin, the mood was altogether quieter, in deliberate contrast to the excitement of *The Dance*; while fiddler and flautist play, the three listeners sit well apart from one another, arms clasping their drawn-up knees, in a seemingly melancholy state of self-absorption. The effect was evidently intentional, since scholars have been able to reconstruct the various stages through which *Music* passed; they have shown that Matisse turned the figures away from one another at quite a late stage in the work, and that he also eliminated cheerful if distracting details such as flowers and a dog.

Before shipping *The Dance* and *Music* to Moscow, Matisse exhibited them at the Salon d'Automne in October 1910. The furore they created seems to have unnerved Shchukin, who in

RIFFIAN STANDING

Matisse's stay in Morocco notably affected his art.
1912. State Hermitage Museum, Leningrad.

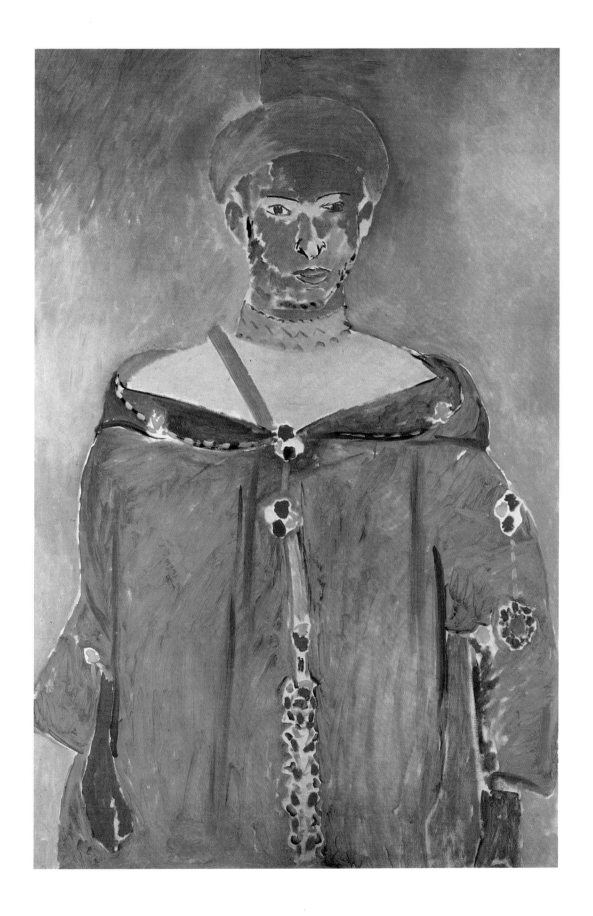

March 1909 had declared himself 'resolved to brave out bourgeois opinion and hang on my staircase a *nude* subject'. In retrospect, his need to make such a statement of defiance showed a certain anxiety about social pressures, which were stronger in provincial Moscow than in Paris, or even in the sophisticated Russian capital, St Petersburg. Shchukin was a public figure was well as a wealthy connoisseur, throwing open his house for concerts of chamber music, and the thought of fashionable ladies encountering *The Dance* and *Music* on his stairs – and perhaps leaving in disgust – cannot have been pleasant to contemplate. When it came to the point, Shchukin refused the pictures, excusing himself on the grounds that he had just adopted two young girls, whose presence in his house would make a public display of nude bodies quite unthinkable. He offered to pay the same price for two new versions, small enough to fit into his bedroom, but Matisse refused; it was one of his most strongly held beliefs that a work of art could not be reproduced on a different scale, but would have to be done afresh. In any case, he was deeply upset by Shchukin's rejection of such major efforts, and in November 1910 left for Spain in disgust. The negotiations that subsequently took place are obscure, but Shchukin changed his mind at some point and (apparently after some efforts to persuade Matisse to retouch *Music*) installed the paintings in his house.

The incident illustrates the strength of late 19th- and early 20th-century prudery, since Matisse's figures are not sensual, let alone sexually provocative, and to our eyes they seem scarcely sexually differentiated. The chief cause of offence was apparently the presence of a male sexual organ on the flautist in *Music*, although Matisse later insisted that it was 'indicated quite discreetly'; and for all his admiration of Matisse, Shchukin did in fact employ someone to paint it

out after it had come into his possession. Matisse remained annoyed enough to bring the matter up over twenty years later, tactfully suggesting to the Soviet art critic Alexander Romm that a little liquid solvent would suffice to restore the picture. By that time, of course, Shchukin's paintings had passed by confiscation into Soviet hands, forming the backbone of the great Matisse collection in the Museum of Modern Western Art (now divided between the Hermitage Museum in Leningrad and the Pushkin Museum in Moscow).

Another of the great collectors of modern art, Ivan Morosov, was also a wealthy Muscovite. Having been introduced to Matisse by Shchukin, he bought a number of the painter's works before 1914, and these, together with more than a hundred other modern masterpieces, also found their way into Soviet museums. Through the accidents of taste and history, then, the greatest Matisse collections outside the United States are in the Soviet Union.

Although Russians and Americans continued to be important patrons, in September 1909 – while engaged upon *The Dance* and *Music* – Matisse was able to free himself from dependence on individuals and their whims. With the help of Félix Fénéon, a critic whose discriminating advocacy of the modern went back to the days of Seurat and Toulouse-Lautrec, Matisse negotiated a contract with Bernheim-Jeune, one of the leading Parisian galleries, of which Fénéon was the business manager. Bernheim-Jeune agreed to take Matisse's entire output of paintings, for which he would be paid at a set rate according to the size of the canvas; he was, however, left free to accept direct commissions from individual clients. The contract, renewed four times between 1909 and 1926 (primarily to raise Matisse's prices), guaranteed that he would be not only secure but well off; and its very existence was of course an indication that there was a ready market for his work.

EXHIBITIONS AND TRAVELS

The gulf between the connoisseur and the wider public, however, remained unbridged. The first and second Post-Impressionist exhibitions in London (1910, 1912), and the Armory Show of 1913 in New York, are now seen as landmarks in the history of modern art as far as the English-speaking world is concerned; but although they introduced the public to the best – but hardly known – painting and sculpture of the previous thirty years or more, mass contemporary reactions remained largely hostile and uncomprehending. Indeed Matisse was particularly well represented at the shows of 1912 and 1913, and came in for a good deal of abuse – although, inevitably, the anti-hero of the Armory Show was Marcel Duchamp, later associated with the 'anti-art' Dada movement. Duchamp's famous *Nude Descending a Staircase, No. 2*, 'the abstract presentation of motion', a painting of vertiginous brilliance, like a series of superimposed photographs of a moving object, was the star attraction for the quarter of a million visitors to the show, who queued up to gaze incredulously at it. Reviewers, however, found time to note that Matisse's art was 'essentially epileptic', the work of 'a nasty boy'. (But then, his sculptures had been dismissed as the work of a madman, a creator of gargoyles, when they had been shown at '291' in 1912.) And when the show went on tour to Chicago and Boston, the students at the Chicago Institute of Art were most incensed by Matisse's *Blue Nude*, which they actually burned in effigy.

Matisse remained outside the fray, but the *New York Times*, which had described his paintings as 'revolting in their inhumanity', published an interview which Matisse had given to a reporter in his house at Issy. Her piece is full of unconscious humour, since there is a constant interplay between her naïve expectations of outrage and the ordinariness of Matisse's person and behaviour. She had expected a long-haired, slovenly, eccentric individual (certain prejudices have an astonishingly long history!) and found instead 'a fresh, healthy, robust blond gentleman'. His house was normal; so was his living-room; a painting he had copied at the Louvre was normal; and, when the reporter left, he politely asked her to come again, just as (she thought) a normal gentleman would . . . Matisse seems to have played up to her, asking her to tell the American people that he was a family man with a comfortable house and fine garden, and stressing his orthodox training at the Ecole des Beaux-Arts. He was not by temperament a rebel, being too serious a man to find much pleasure in shocking other people, and he was certainly anxious to dispel the philistine notion that artists who did not slavishly copy nature must be technically incompetent. He explained his ideas to the reporter as simply as possible, trying to make her understand that an artist might want to paint what he felt about an object rather than reproduce the exact appearance of the object itself; but Clara T. MacChesney left his house still convinced that, if Matisse himself was a 'normal gentleman', his work was 'abnormal to the last degree'. She had picked up the idea that Matisse's paintings were intended to refresh the tired mind (she had probably been reading 'A Painter's Notes'), and remarked at the end of her article that she would not have dared to expose her weariness for long to Matisse's *Cathedrals at Rouen*. Had the reporter said this to Matisse himself, he might possibly have sympathized: the *Cathedrals* are a series of paintings by the Impressionist Claude Monet.

Although Matisse did not cross the Atlantic, he travelled quite extensively in the years before the First World War. He later referred to this as his 'period of new acquisitions', when, beginning with his trips to Biskra and Italy, his artistic

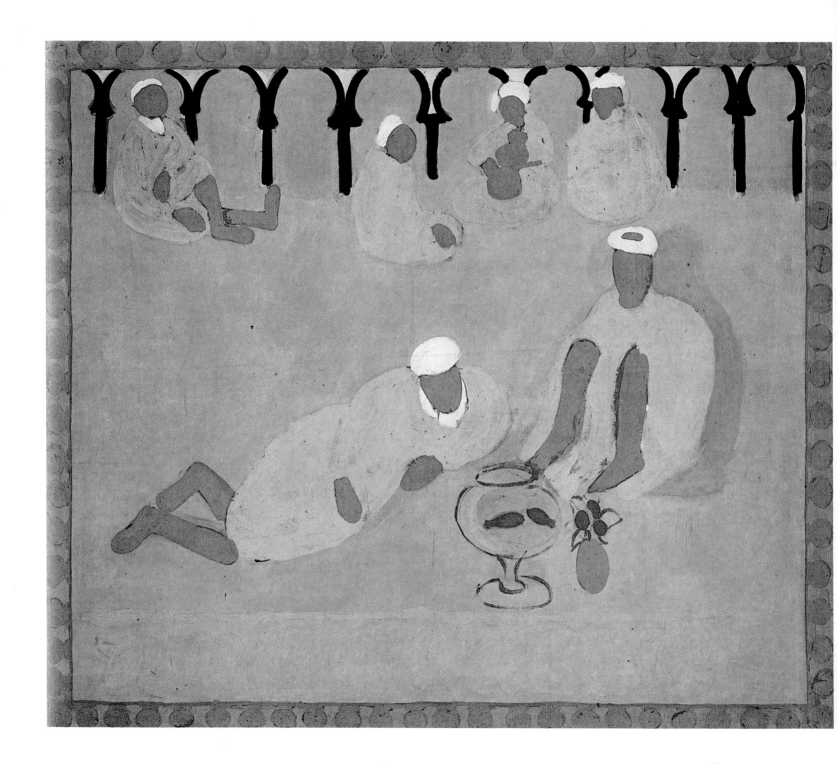

ARAB CAFE

A very large, rather enigmatic reminiscence of Matisse's visits to Morocco.
1912–13. State Hermitage Museum, Leningrad.

outlook was influenced by a series of new experiences. One of the most important seems to have been the exhibition of Islamic art at Munich, which Matisse and Purrmann visited in the late summer of 1910. The jewel-like quality of Islamic decoration probably helped to reawaken Matisse's own decorative impulses, and *The Painter's Family* (1911) in particular has a density and ruby brilliance reminiscent of Persian and Mogul miniatures; but whereas Islamic painters simply ignored perspective and similar Western pictorial devices, Matisse employed them selectively to create a new and sophisticated art, which is neither 'Western-realistic' nor 'Islamic-patterned' in its entirety. The extra-ordinary dense patterning of *Interior with Aubergines* (1911), for example, creates a surface that is, at first sight, carpet-like in its flatness; yet, by the careful placing of overlapping objects in the interior, and the use of a restricted number of perspective-suggesting lines, Matisse has also created a perfectly 'legible' scene in the Western tradition.

Matisse's stay in Andalusia during the winter of 1910/11 had less impact on his work, although it occasioned two riotously colourful still lifes of Spanish shawls. The 'Espagnolisme' that occurred in his pictures from time to time was of the superficial romantic variety – something of a tradition in French art and letters – and had already been seen in, for example, *Spanish Dancer with a Tambourin* (1909). His trip to Spain had been in part an antidote to his depression after Shchukin's refusal of *The Dance* and *Music*. Having changed his mind again, Shchukin invited Matisse to Moscow in the autumn of 1911, probably to advise the Muscovite on the hanging of the large decorations or other pictures. (All Matisse remembered was that his paintings were shown to poor effect because Shchukin had followed convention by masking their surfaces with glass and hanging them at an angle to the wall;

later, presumably as a result of Matisse's advice, he seems to have taken away the glass and hung the pictures in modern fashion, flush against the wall.) Thanks to *The Golden Fleece* magazine and its exhibitions of 1908 and 1909, Matisse was well known in Moscow and was treated as something of a celebrity on his arrival. He reacted graciously to this attention, effusively admiring Russian icons and asserting that they provided a better source of inspiration for modern artists than anything to be seen in the West. Matisse's enthusiasm was no doubt sincere, but contact with icon painting had no discernible influence on his work, despite the emotional impact of the Russians' powerful designs; the hieratic gravity of icons was not entirely compatible, perhaps, with his own outlook.

Many years later, in a less gracious mood, Matisse described Moscow as having been 'like a huge Asian village', and declared that he had never derived much benefit from travel because he was 'too anti-picturesque'. This was hardly true of his reactions to Morocco, where he spent several months during the winters of 1911/12 and 1912/13. It might have been more accurate to say that he was 'pro-sun' (he had complained of having 'frozen brains' in Seville, and of the 'appalling' downpours in Moscow). The splendid weather did his health good, and the visual impact of the Moroccan scene was overwhelming. The people and their surroundings were colourful and exotic, and the light outlined and flattened objects even more dramatically than it did in the South of France. As a result, Matisse painted some of his most 'Islamic' pictures – among them the only ones in his *oeuvre* that might actually pass (except in terms of scale) for the work of a non-Western artist; the outstanding example is *Zorah Standing* (1912), frontally posed and painted with pure colours just like a miniature. Zorah was evidently his favourite Moroccan model, but there were

several others, including a magnificent Riff tribesman who seems to have greatly impressed Matisse; two large portraits of him exist, both well over life-size. Matisse quite obviously revelled in the brilliance of Morocco, painting individual figures, a huge and mysterious *Arab Café* (1912–13), views from windows, and garden scenes in which his delight is almost palpable. The collectors sensed it too, and (Shchukin and Morosov to the fore) rushed to purchase.

Interestingly enough, Matisse – although supposedly 'anti-picturesque' – painted in quite a different style when absent from picturesque Morocco and back at Issy during the rest of the years 1912 and 1913; some of his work displays an angularity and structural emphasis that may have been a belated response to Cubism. However, he still enjoyed playing with the painting-within-a painting, and in 1912 executed two tall, narrow pictures on the subject of *Nasturtiums and 'The Dance'*, in which a chair and a vase of nasturtiums on a tripod are shown in an apparently arbitrary section of an interior with part of *The Dance* (Matisse's full-scale preliminary study, not Shchukin's *Dance*) as a wall painting behind them. The way in which the heads and limbs of the dancers are cut off by the edges of the canvases gives an interesting 'snapshot' effect which had

been exploited by the great French painter Edgar Degas (1834–1917) and the masters of the Japanese print, but had not normally been used by Matisse himself.

In April 1913, while Matisse was being given a one-man show at the Bernheim-Jeune gallery, his long-time patron Marcel Sembat was writing of him in a periodical as 'a fabulous personage' about whom there was wild speculation. Was he a practical joker? Was he mad? Was it true that he was making a fortune and lived in a château? . . . Matisse, still only forty-four (wrote Sembat, actually a little prematurely), was 'cloaked in legend'. But although his works remained controversial in his native France, elsewhere Matisse's reputation was becoming more solidly based. In October 1913 Shchukin wrote Matisse a letter describing his abiding delight in *The Arab Café* and recounting a visit he had received from no less than ten German and Scandinavian museum directors; all of them had looked at Shchukin's Matisses and agreed that he was 'a great master'. Furthermore, Berlin did eventually make amends for the disastrous 1908 show; a one-man retrospective was arranged, with paintings by Matisse going back to the late 1890s. The show opened in mid-July 1914, only to be interrupted within a fortnight: the First World War had broken out.

NASTURTIUMS AND 'THE DANCE'

The first of two paintings on the subject. The background is a painting-within-the-painting – part of Matisse's The Dance, *a full-scale study for the work of the same name which he executed for the Russian collector Sergei Shchukin. 1912. Pushkin Museum of Fine Art, Moscow.*

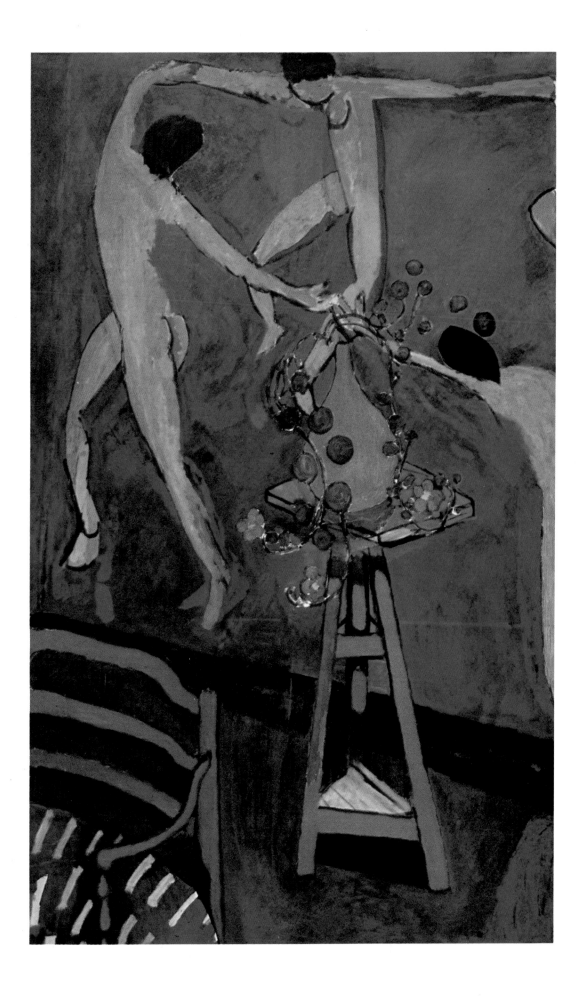

SHADOWS
AND
SUNLIGHT

The profound impact of the First World War on European life is well known. Mass armies of conscripts and the tactics of trench warfare ensured that the slaughter would be on an unprecedented scale and would afflict every section of the community. Among artists and architects, the fatalities included such gifted figures as Henri Gaudier-Brzeska in France, Franz Marc in Germany, and Umberto Boccioni and Antonio Sant' Elia in Italy; others, like Matisse's first literary champion, the poet and critic Guillaume Apollinaire, were carried off by the influenza epidemic that swept the world in the wake of the war. Matisse himself reported for military service in August 1914 but was rejected. The closest he came to direct involvement in the war was at the very beginning, as a Parisian civilian threatened by the first great German offensive (halted at the Marne), which prompted him to take his family south to the safety of Toulouse and Collioure. But the atmosphere of the war affected him as it affected so many other civilians. For a year or so he found it difficult to work, and later on we find him referring enviously to Derain, who had visited him from the front. Matisse observed a certain exaltation in his younger friend's outlook which caused him to express the common wartime feeling that it might be worth the risks to be involved in the tumult rather than to remain 'irrelevant' on the sidelines. As if in need of distraction, he took up the violin, which he had played regularly in former years (on one occasion he had even taken part in a duet with Vlaminck, who performed to near-professional standard). He practised obsessively and exhaustingly, at-

tempting to shut out the war – as, in a like manner, he was to become an obsessive cinema-goer in the early part of the Second World War. However, when he asked the Minister of Public Works – his old friend Marcel Sembat – how he could help the war effort, Sembat told him that the best way was to go on painting good pictures.

Whatever Matisse's personal feelings, it is open to question whether the war had any significant influence on his art. It is true that his paintings of 1914–18 are relatively sombre, as might be expected at a time of national crisis; but this tendency was in fact visible in Matisse's work some years before the war. At least as far back as *The Blue Window*, painted at Issy in 1911, the straight lines and geometricized shapes usually associated with Cubist art had begun to appear in his paintings, while the 1913 *Portrait of Madame Matisse* and the *Woman on a High Stool* of 1913–14 showed a progressive and surprising tendency towards sobriety of colour. Matisse's preoccupation with the intellectual, structural elements in a painting – sometimes called his 'architectonic' phase – remained strong throughout the war years, although his treatment of them varied widely; in particular, some pictures convey a consistent sense of depth, while others are all 'surface', so that the impact of their patterning comes close to obliterating any realization that they are fundamentally representational in style.

This development did almost certainly owe something to Cubism, which had become the chief avant-garde movement, led by Picasso and Braque. Matisse was in at least casual contact with Picasso himself, and on a number of occasions in

PORTRAIT OF MLLE YVONNE LANDSBERG

A rather uncharacteristic painting, somewhat reminiscent of Picasso.
1914. Philadelphia Museum of Art, Louise and Walter Arensberg Collection.

1913 the two men went riding together (the more experienced Matisse, it is said, setting a pace that left Picasso thoroughly shaken up by the end). The contact is likely to have had some influence on both, for two such compulsive workers would not have spent their time together discussing indifferent topics. It may not be entirely a coincidence that at the very time when Matisse was confronting problems of structure and restrain-ing his colouristic impulses, Picasso was about to abandon his monochromatic 'analytical' Cubism for a 'synthetic' style in which he employed a brighter palette. Matisse's new preoccupations were probably reinforced by his friendship with Juan Gris, a Spanish Cubist whom he met at Collioure in September 1914. Confronted with Gris's passion for ideas, Matisse became involved in bouts of ardent theorizing for the first time in

Above

PORTRAIT OF PIERRE MATISSE

*A portrait of the artist's younger son, who was to become an art dealer in
New York.*
1909. Private collection.

Opposite

THE GIRL WITH THE BLACK CAT

A portrait of Marguerite Matisse, the painter's daughter.
1910. Private collection.

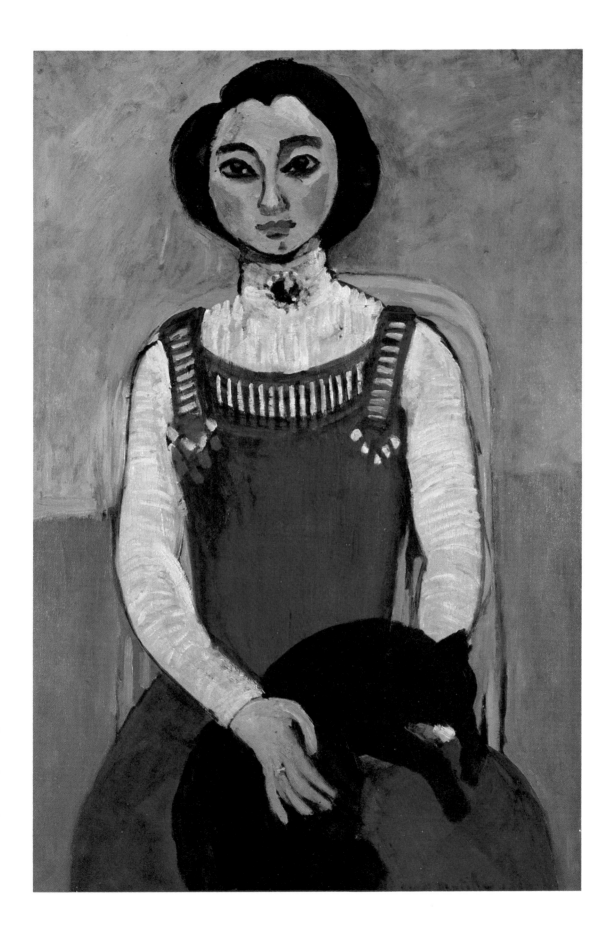

years. The two men talked relentlessly; Marquet joined them but mainly listened ('I think he's rather bored,' Gris told a friend).

The international prestige of Cubism was such that the movement had begun to produce a crop of imitators and offshoots. The Italian Futurists, for example, took over many features of Cubism but allied it to an intellectually dubious, proto-fascist cult of 'dynamic' action and speed. By the use of repeated, sequentially placed facets of an object, or of parallel contours, they sought to give the illusion of movement, a technique Matisse seems to have used only once, in his curious *Portrait of Mlle Yvonne Landsberg* – curious in that it is so un-Matisse-like, with a face (or mask) reminiscent of Picasso's *Demoiselles d'Avignon*, which it also resembles in a certain fierceness of mood. Such is the oblique relationship between life and art that this canvas, which might easily be interpreted as a symptom of wartime tension, was in fact painted in the spring of 1914, before the assassination at Sarajevo and the mobilization of the armies.

It is even more tempting – and may in fact be correct – to interpret one of Matisse's pictures, painted at Collioure in the autumn of 1914, as a more or less direct response to the outbreak of the war. *Open Window at Collioure* was more radical than anything the Cubists had done, and could well have been exhibited with some claims to originality as late as the 1950s. The window opens on to blackness; in an austere formal arrange-ment, window, wall and shutters are reduced to a few rectangles of uniform colour, so lacking in identifying features that they might well be re-garded as elements in a purely abstract painting, but for the existence of a title that relates the picture to external reality. But the title is also one that prompts further speculation, since a window open on to a landscape is one of Matisse's great subjects, normally associated with the joy of

brilliant colouring and the natural world. Is the absence of nature and colour in this *Open Window* an expression of Matisse's feelings about life and work in the autumn of 1914 – that, in literal terms, there was nothing to be seen ahead but darkness? We can be sure that Matisse would have denied such a 'literary' interpretation, but this is perhaps a case in which the unconscious played an even greater part than usual in the creative process. However, it must also be said that Matisse painted a similar but less sombre, quasi-abstract open window – *Composition: Yellow Curtain* – in the even gloomier year 1915.

During 1914–15 Matisse found it difficult to paint, but he spent a good deal of time on printmaking, to which he had devoted no atten-tion since 1906. He made some sixty-odd etchings and drypoints (an engraving technique in which the drawing is done on the metal plate with a steel 'pencil'), many of them pleasantly sketchy por-traits of friends. The nine or ten lithographs he executed were all of female nudes, and for these he exploited the thick, rich line given by the lithographic chalk to create drawings of the utmost economy, such as *Nude Seated, Showing her Back* and *Nude in a Rocking Chair*. Finally, he made a handful of striking white-on-black mono-types – prints from which only a single impression could be taken; they were done by scratching a few lines on a heavily inked plate, which therefore printed the negative (undrawn) areas black. Given the technique employed, the monoprints were necessarily simple, displaying Matisse's evocative power at its most effective; in both monoprints and lithographs, each image is complete and sufficient although it may consist of no more than a torso or a head and breasts.

In 1916 Matisse recovered his creative powers as a painter, executing a series of monumental canvases that constitute his least characteristic but by no means least significant masterpieces.

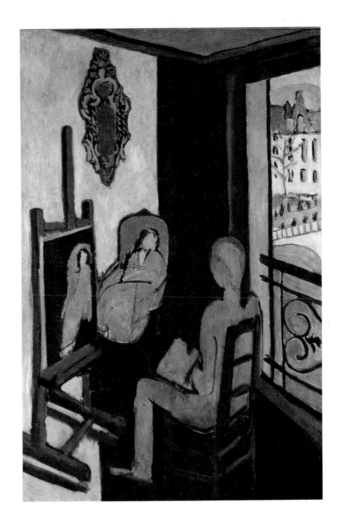

Two in particular were inspired by memories of Morocco: the large *Moroccans* (1916) and the even larger *Bathers by a River* (1916–17), which is almost thirteen feet (just under four metres) long. In the pre-war period, the colouristic exuberance of Matisse's Moroccan paintings seemed to contradict the more austere impulses apparent in his other works; now it appeared that he was attempting to bring the two together, as if determined to subdue even the splendour of North Africa with the weapons of pattern and geometry. In *The Moroccans*, a turbaned head, melons ripening on a frame and the blue-and-white striped leaves of a potted plant are related circles of colour; the sharp edges of buildings and objects float on an unbroken black ground. If schematization were carried a short step further, the scene would be transformed into a purely abstract arrangement of

THE PAINTER AND HIS MODEL

Matisse always enjoyed putting his own past works among the impedimenta of a new picture. Here he takes the device a stage further and depicts himself in the act of painting the well-known Green Robe.
1916. Musée National d'Art Moderne, Paris.

colours and shapes. Characteristically, Matisse preferred not to take such an important step: the picture remains 'legible' with a little effort, and is even evocative of its exotic subject. The same is true of *Bathers by a River*, despite its anonymous Cubist-style nudes and the strict vertical partitioning of the canvas: the alternating bands of black and yellow suggest the abrupt transitions from North African sunlight to shadow, while the sharp-edged leaves and a single snake place the scene in nature.

Another important subject in this period was the interior of the painter's studio (*Studio at the Quai Saint-Michel*, 1916); and Matisse himself appears in his own creation with the Pompidou Centre, Paris, version of *The Painter and His Model* (1916). In the latter, the cross-referencing is carried further still, for the painter is obviously at work on *The Green Robe*, the best-known of many paintings executed at this time with Laurette, a dark-haired Italian model, as the subject. The studio at the Quai Saint-Michel shown in these canvases was the very one he had earlier occupied for years. In 1913, finding Issy a depressing place in which to work during the winter, he had rented the studio again and resumed his old habits, even to the extent of painting views of Notre-Dame through the window.

However, much of Matisse's work was still done at Issy, and his family remained among his most important sitters. His daughter Marguerite was the subject of numerous charming portraits such as *Marguerite Reading* (1906), *The Girl with the Black Cat* (1910) and the grown-up *Marguerite in a Fur Cap* (c. 1917); she was evidently a better or more willing subject than Matisse's sons Jean and Pierre, whose appearances in his work are quite infrequent. However, Pierre is the hero-victim of the extraordinary *Piano Lesson*, a solitary small boy imprisoned behind a large Pleyel piano. The painting is fascinating but arouses ambivalent responses. Formally, it is immensely satisfying – a harmony of cool colours, predominantly grey, laid out in flat areas of subtly related geometry; but the shuttered room creates a feeling of oppression, and a wedge of colour that obliterates one of the boy's eyes, although effective in echoing similar shapes in the picture, introduces a strange, possibly unintentional, note of surrealist unease. *The Piano Lesson* appears to date from 1916 or early 1917 and, if so, was painted before the closely related *Music Lesson* of summer 1917. Since *The Music Lesson*, although later, is a far more 'realistic' work, the sequence reverses Matisse's normal progression from literal to increasingly formal or abstract effects, and has

THE GREEN ROBE

This painting is shown as a work in progress in The Painter and his Model, *dating from the same year. The model Lorette appeared in a number of his pictures around this time,* The Green Robe *being one of the finest.*
1916. Private collection.

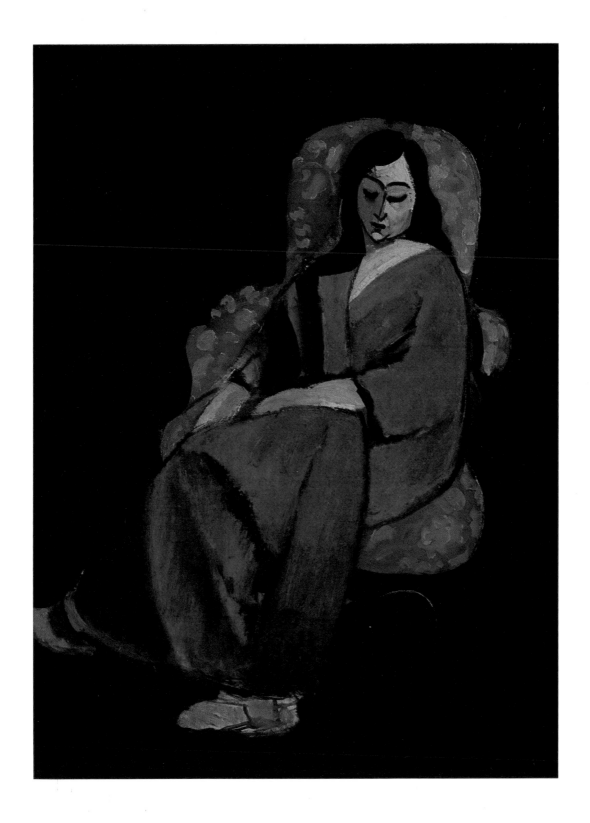

therefore been interpreted as a symptom of his general movement away from sobriety and geometry. The setting of *The Music Lesson* is unmistakably the same as that of the earlier canvas, but everything in it has been humanized: sobriety, solitude and claustrophobia have been replaced by familial warmth. Pierre is not alone at the Pleyel, but sits at the instrument with his sister Marguerite; in the bottom left-hand corner, instead of a statuette, Pierre's brother Jean, already a young man sporting a moustache, sits reading and smoking; Matisse's violin, on the piano, indicates the father's presence; and through the shutters – now open – Madame Matisse sits sewing beside the pool.

A certain relaxation also appears in Matisse's landscapes of 1916–17, mostly painted in the Bois de Meudon, a large parkland area quite close to Issy. *Trivaux Pond*, in the Tate Gallery, London, is typical of these works; it possesses a quiet structural strength derived from the pictorial arrangment of bare tree trunks and branches, but the colours – autumnal greens, browns and blues – are not flat but subtly blended to create a lovely damp woodland atmosphere.

Although the transitional period was quite protracted, Matisse was indeed entering a new phase: one in which he would put aside the structural problems that had haunted him, and would give free rein to his colourist's instinct, painting with greater freedom than ever. The change was intimately connected with his residence at Nice – although, as so often in Matisse's life, it would be difficult to separate cause and effect: he may have changed his way of painting as a result of staying in Nice, or – perhaps more likely – he may have chosen Nice because it met a growing need in him for light, colour and pleasure. At any rate, Matisse's published statements leave us in no doubt that he felt it the height of good fortune to be able to dwell in this southern city, where he awoke every morning with a thrill to see the light pouring in through the shutters; and for a decade or more his paintings were to mirror his responses to this and to other pleasures of the senses.

Matisse's move to Nice was a gradual affair, carried out in stages. Initially, in December 1916, he went south to avoid the rigours of the winter, and booked into the Hôtel Beau-Rivage on the Promenade des Anglais. According to his own account, it then rained for a month, and he was on the point of going away in disgust when the weather changed; at once Matisse was enchanted, and as a result, 'I decided not to leave Nice, and have stayed there practically the rest of my life.' Actually he wintered in the city for five years before finally committing himself, since he stayed mainly at the big seafront hotels until he took an apartment in a large block on the Place Félix in 1921. Even then, strictly speaking, Nice was no more his home than Issy, for Matisse divided the year about equally between North and South, usually spending the months between December and May on the Riviera; but he himself always spoke of Nice with grateful fervour, and there can be no doubt that, in his mind, it was what Henry James called 'the Great Good Place'.

Rich, famous and almost fifty, Matisse might have looked on Nice as a place for an early retirement. In fact, as he told the critic Tériade, 'I worked at Nice as I would have worked anywhere'; his only concession to the playboy atmosphere of the Riviera was to become a member of the Club Nautique and to take more exercise by rowing regularly. For the rest, his routine was private and laborious. After an early breakfast he played the violin for an hour (in the remotest hotel bedroom, to avoid disturbing other guests); then he would paint in his room or out of doors until dark, with a break for lunch and an occasional visit to the local Ecole des Arts Décoratifs,

where he could do a little modelling or draw from plaster casts. In the evenings he drew or, like a good Frenchman, went out to meet his friends, such as the novelist Jules Romains, in a café. He also sometimes visited two painter-friends who lived along the coast: the aged arthritic Renoir, one of the great figures of Impressionism, and Pierre Bonnard, who was only two years older than Matisse but had made his greatest public impact in the 1890s, before Matisse's career as a 'modern' painter had even started. It is probably no coincidence that both Renoir and Bonnard were primarily associated with the kind of painting Matisse was now embarking on – pleasurable scenes of beautiful women, often in light-filled interiors; scenes redolent of the traditional pleasures of food, wine, sunshine and love-making.

During Matisse's second winter in Nice (1917/18) he painted *Interior with a Violin*, a splendid still-life interior that is transitional in an almost symbolic way: it has all the formal strength and sombre colouring of Matisse's great 'architectonic' canvases, but now, although the room is darkened, one shutter is open, light pours into one corner of the room, and outside we can see the brilliant colours of the South. Almost the last sign of architectonic austerity occurs in the well-known self-portrait early in 1918. Even the human content remains severe; the bespectacled middle-aged man, dressed in a suit and tie to sit at his easel and paint, seems a world away from the apparently tough 'wild beast' who looks vigilantly out of the 1906 *Self-Portrait*. All the same, Matisse has his little private joke in this self-confrontation: behind the artist, leaning against the washstand, is an umbrella in a waste-paper bin, surely a reminiscence of that first rainy month in Nice when he was confined to his room with, he said, nothing to paint but . . . his umbrella in a waste-paper bin.

A similar light-heartedness appears in other works of the period. The most curious is the long series of paintings and drawings in which the model Antoinette wears a grandiloquently large plumed hat that Matisse himself made from straw, feathers and ribbon. Here he seems to have aimed at a virtuoso display, using a variety of painting and drawing techniques and posing the model in a range of costumes (and also half-naked, her plumed hat, drapes and heavy breasts creating an odd 'wedding dress' effect). Furthermore, the model's appearance alters from one painting to the next: she is shown variously as child-like and mature, baby-faced and severely handsome. It is as though Matisse were insisting on the artist's role as master of make-believe, privileged to manipulate reality acording to his whim: in his two-dimensional world the model becomes a kind of slave, her role and her very appearance lying in the power of the magician's wand. Though never again so overt, this feeling is present in much of Matisse's work in the 1920s: the studio interior becomes his pleasure-palace, where he is the pasha, alone with his odalisques.

By 1919 the new mood was fully established in two paintings that invited comparison with previous works by Matisse. *The Painter and His Model* is the opposite in almost every respect to the painting of 1916 on the same subject: it is smaller and more intimate, closer to everyday reality, crowded with lively decoration, and executed with an apparently cursory touch; the painter in his pyjamas is visibly the bearded and bespectacled Matisse, the model a voluptuously lounging nude. Similarly, the *Interior with a Violin Case* of 1918–19 announces a change of stance from that of *Interior with a Violin*: the setting is more spacious and luxurious, consonant with the superior hotel to which Matisse had moved, and its balconied french window has been thrown open, filling the room with a light that emphasizes the opulence of its decoration.

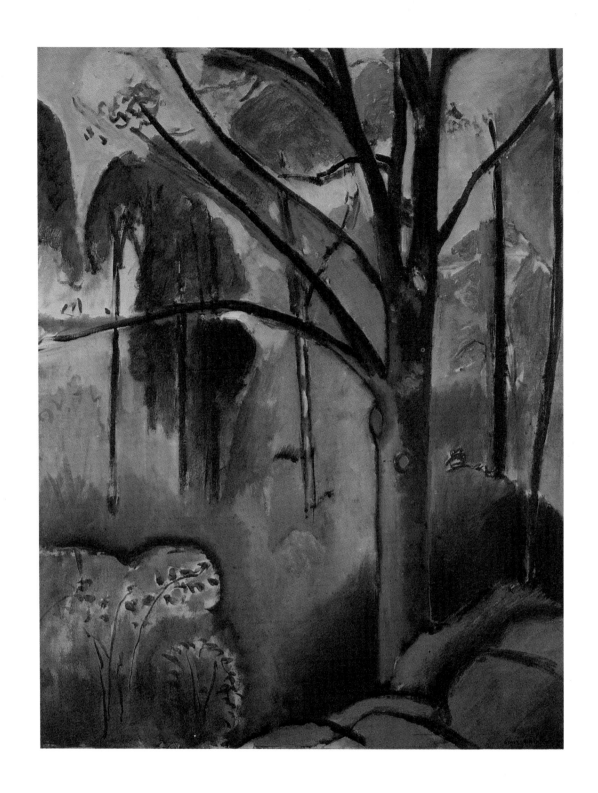

TRIVAUX POND

*Matisse produced some fine landscapes during the war years, notably his poetic
rendering of a misty wood.
1916 or 1917. Tate Gallery, London.*

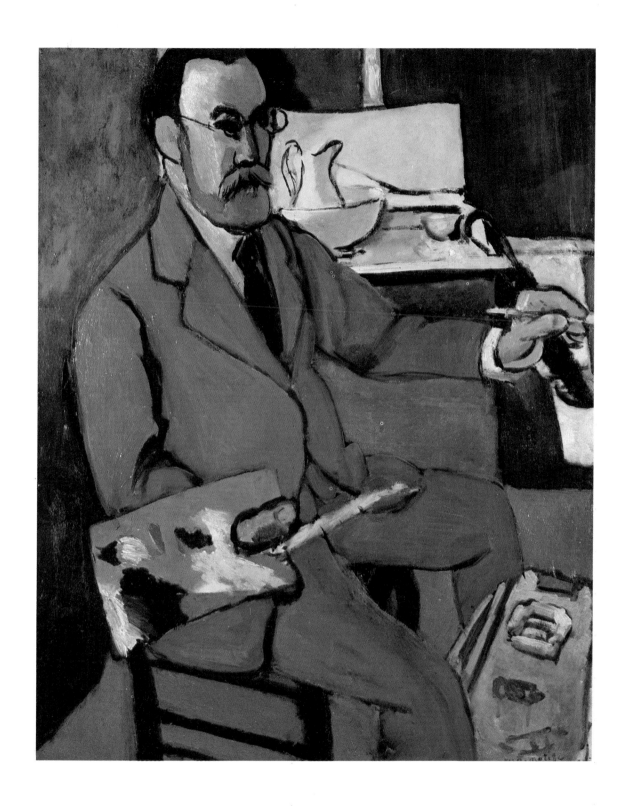

SELF-PORTRAIT

The austere, respectably dressed figure of the painter stands in stark contrast to the self-portrait of 1906.
1918. Musée Henri Matisse, Le Cateau.

One of Matisse's fundamental convictions was that an artist should never allow himself to become the prisoner of his own success; he liked to quote with approval the great Japanese painters, who made a habit of changing their names and starting afresh several times in the course of their lives. And, certainly, in Matisse's own work we have found him launching out in a new direction at the very moment when he seemed set on a specific course, as if moved by a powerful impulse of self-contradiction. Something of the sort may have persuaded him to spend part of two summers (1920 and 1921) at the fishing village of Etretat on the coast of Normandy, painting an environment as unlike his closed world at Nice as he could find. Artists had been drawn to the spot since the mid-19th century when Courbet and Monet had worked there. A considerable attraction, visible in the background of Matisse's Etretat landscapes, was the 'Elephant', a rock hollowed out by the action of the waves into a trunk-like arch. Matisse had come to Etretat in 1920 after a visit to London for the opening of *The Song of the Nightingale* (*Le Chant du Rossignol*), a ballet for which he had designed the sets and costumes. Although commissioned by Serge Diaghilev and performed by the famous Russian Ballet, the piece made no great impact, and in avant-garde circles there was some criticism of Matisse's costume designs as no better than fashion-plates. This was in line with critical reaction to his more relaxed style of the 1920s, which modernists were inclined to interpret as a flagging or betrayal. On the other hand, this style – and the sensual ideal it embodied – made Matisse's painting widely popular for the first time among Frenchmen. All the same, most of the actual purchases continued to be made by foreigners – now mainly Americans and Danes, since the Revolution had put an end to Russian buying.

In spite of diversions, the pleasurable/ tra-
ditional character of Matisse's work persisted into the late 1920s. With his children grown up, he turned away from domestic subjects, and the female model – always important to him – now became his central preoccupation. For a time, the nude was less in evidence in his work than what may be called 'the post-war girl' and the odalisque. The post-war girl – that is, a fully dressed female figure, unmistakably the product of the new age, with bobbed hair, brighter clothes, shorter skirt and high heels – evidently delighted Matisse, who put her into such paintings as *The Inattentive Reader* (1919), *Large Interior, Nice* (1921), *Reading Woman with a Parasol* (1921) and *Woman on a Divan* (1922). Usually there is only a single girl; the few exceptions represent occasions when Matisse's daughter Marguerite was staying with him. Then he posed her with a model, in the garden at Issy in the large, curiously jokey *Tea* (1919), and in a number of paintings done in Nice during 1921, culminating in another large canvas that combines extreme ornateness with a sense of Twenties sophistication, *The Moorish Screen*. Similar figures appear in the lithographs that Matisse began to produce regularly from 1922; in these he abandoned the brevity of his 1914 style and adopted a more 'painterly' approach, with delicate shadings and sometimes elaborate backgrounds, as in *Girl Seated in a Chaise-Longue in a Landscape* (1922) and *Girl Leaning on Her Elbow in front of a Flowered Screen* (1923).

Another lithograph, the wonderfully svelte, satin-skinned *Girl in Striped Pantaloons* (1925), represents the purest wish-fulfilment version of Matisse's abiding obsession with the odalisque; her rival among Matisse's paintings is perhaps the luxurious *Odalisque with Magnolias* of 1924. The odalisque, or harem girl, is all the more erotic for being partly clothed, and Matisse painted and drew her again and again, wearing pantaloons or an open jacket, or flaunting the gauzy trans-

parency of tulle. The pantaloons and other accoutrements were of course intended as exotica, not as authentic historical costumes. Matisse's odalisque is as often as not the short-haired 'post-war girl', as seen in the *Striped Pantaloons* – and, for that matter, in this particular work she is (in Matisse's imagination) not Moorish or Turkish but Indian, as the French title of the lithograph, *La Culotte Bayadère*, suggests (*Bayadère* means Indian dancing girl). The odalisque is a fantasy woman, existing solely for the painter's pleasure, in his own enclosed kingdom.

READING WOMAN WITH A PARASOL

Women's postwar fashions provided a fertile source of inspiration.
1921. Tate Gallery, London.

91

Above

THE INATTENTIVE READER

Matisse appears to have shared the postwar mood of escapism; the short-skirted 'Jazz Age' girl figures in many of his paintings, and the emphasis is very much on simple, traditional pleasures.
1919. Tate Gallery, London.

Opposite

THE MOORISH SCREEN

A very large painting which interestingly combines 1920s 'modernity' – the girls – with dense 'oriental' decoration.
1921. Philadelphia Museum of Art.

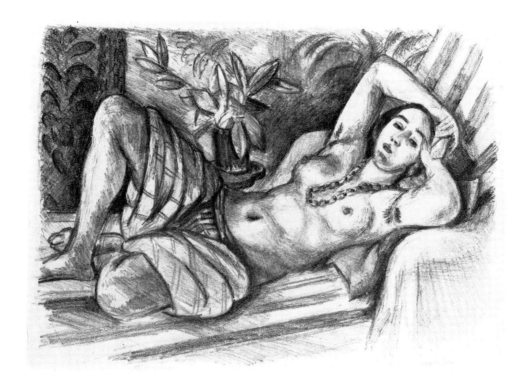

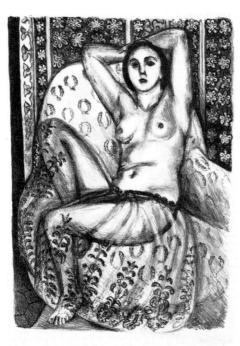
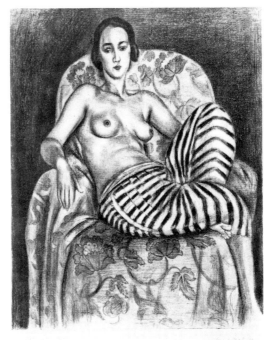

It can be objected, with justice, that there is something not entirely admirable about this repeatedly presented view of woman as a pasha's mindless plaything. And the odalisques are only the most extreme example of this tendency in Matisse's work; apart from the beautiful, reflective *Meditation* (*Après le Bain*), only a few portraits before the 1930s indicate the existence of personality in a woman, let alone intelligence. On the other hand, Matisse's painting is not about 'the confusions of intellect' or social relationships; and if the serene 'art of equipoise' he created is woman-centred, that is largely the fault of the post-Renaissance tradition within which he worked, a tradition that made the female body the image of harmony and pleasure. (The ancient Greek tradition, as displayed in their sculpture, was quite different.)

If Matisse's odalisques represented a form of self-indulgence, it was a uniquely laborious self-indulgence. He continued to work as relentlessly as ever, deeply under the spell of intense decoration but none the less making colouristic and formal experiments that belie any notion that he was simply repeating himself. From about 1923 he became obsessed with the artistic problems inherent in a particular pose, and returned to it again and again. The pose was that of a seated model with her hands behind her head and elbows akimbo, while one of her legs was raised and bent so that the foot was tucked in behind the bent knee of the lower leg. As so often when he was

Opposite, above

ODALISQUE WITH MAGNOLIAS

Matisse followed this lithograph with a painting in which the composition was identical but reversed.
1923. Victoria and Albert Museum, London.

Opposite, below left

ODALISQUE WITH A TULLE SKIRT

Matisse's apparent obsession with odalisques was a way of resolving the artistic problems presented by a certain pose.
1924. Victoria and Albert Museum, London.

Opposite, below right

GIRL IN STRIPED PANTALOONS

From 1922 Matisse began to produce lithographs regularly. This sensual, enticing 'harem girl' has a distinctively Western hair style.
1925. Victoria and Albert Museum, London.

95

worried by a formal problem, Matisse tackled it in several media until one of them provided a satisfactory answer or he had exhausted his interest. The pose is seen, for example, in the painting *Odalisque with Raised Arms* (1923), in the painting and lithograph of *Nude on a Blue Cushion* (1924), and in the bronze *Large Seated Nude* (1925), which signalled a renewal of Matisse's serious interest in sculpture after a dozen years during which he had produced only a handful of small pieces.

In the later 1920s a certain unease became apparent in some of Matisse's work, although his sensual and decorative impulses remained powerful. In painting, his colours became increasingly strong, as though he felt an urge to challenge the supremacy of the model by intensifying the background to the maximum. In consequence, the model had to be enlarged, solidified, and finally, in *Decorative Figure on an Ornamental Background* (1927), distorted into a compact, almost geometrically straight-backed figure like an idol, chunky and assertive enough to avoid being overwhelmed by the utter riot of decoration with which she is surrounded. This development seems to have proved a cul-de-sac, since it obliter-

ated the femininity of the model which, in painting at least, Matisse was no longer prepared to dispense with. In the following years his odalisques made a partial return to softness and sensuality. In general, the works of the late 1920s – odalisques, nudes, dancers, still lifes – were rather less homogeneous, less comfortably enjoyable, and less straightforwardly realistic than their counterparts earlier in the decade; but there was no clear sign in their variety that Matisse might have discovered a new direction for his art. Sculpture, drawing and printmaking continued to absorb him, and his sculpture in particular showed a tendency to retrospection, as if he were scanning the past for a way forward into the future. From 1927 he worked on a subject that had preoccupied him twenty years earlier, producing the bronzes *Reclining Nude II* and *Reclining Nude III*; and in about 1930 he modelled *The Back IV*, ending the series with a grand simplification that critics might have supposed to be beyond the popular painter of Nice.

Matisse was probably well aware that he was not making progress and needed some enlivening experience. At any rate, he decided to go on his travels again.

ODALISQUE IN RED PANTALOONS

Matisse's fantasy of the odalisque or harem girl appears again and again in his paintings and graphic works of the 1920s.
1922. Musée National d'Art Moderne, Paris.

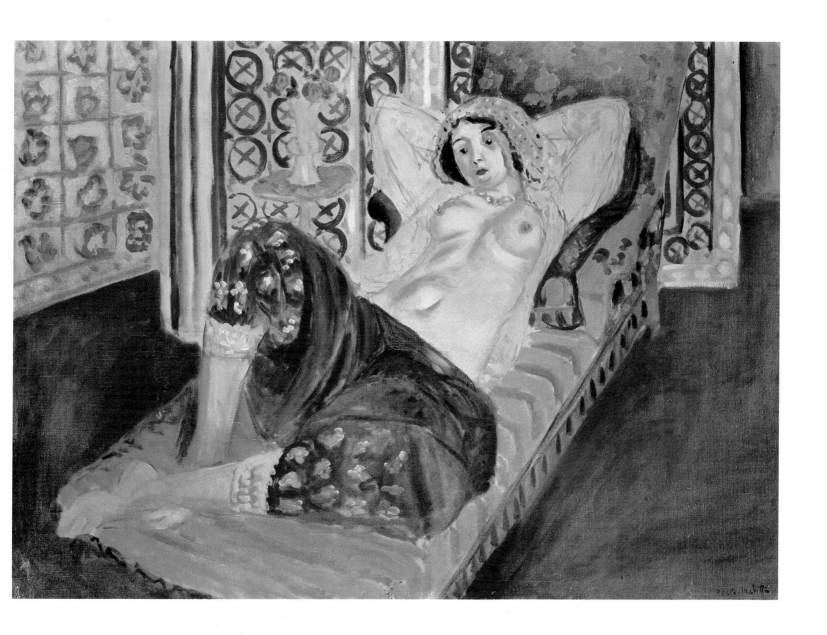

THE
DRAWING
MASTER

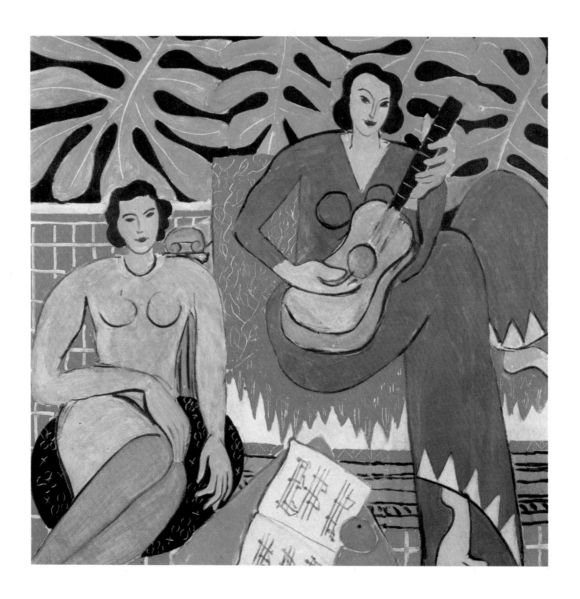

In March 1930 Matisse left France for Tahiti. He had dreamed of visiting the South Sea Islands for years, believing he might find a whole new world of light and colour there; and Tahiti possessed a double appeal , for its romantic name and for its association with Paul Gauguin, the great French painter who had rejected Europe and settled in Polynesia. Matisse journeyed to New York where his son Pierre had set up as an art dealer, and then across the United States to San Francisco, where he took a ship for Tahiti. New York impressed him deeply: its huge size and towering, un-European skyline were symptoms of something new indeed, from which he predicted that a new art would eventually emerge. A few months later, encountering a young American painter on a French train, Matisse informed him in no uncertain manner that American artists had everything they needed – beautiful skies and beautiful women – in their own land, and should therefore stay at home; in fact, 'Artists should stay in their own countries.'

This was exactly the conclusion Matisse drew from his stay in Tahiti, which he generally referred to in dismissive terms. It was 'superb and boring': life presented none of the anxieties on which Europeans thrived; the people were mindless and torpid, without the energy or motive to do wrong (why steal a bicycle when there's no reason to go anywhere?); and the day began with a furious beauty that never varied until nightfall. This summary of his intermittent grumbles suggests that Tahiti was, in many respects, an earthly equivalent to the world Matisse created in his paintings – calm, carefree and beautiful; and

perhaps that was what was wrong with it: there was no place in it for a transforming imagination such as Matisse possessed. As a result, his Tahitian output was restricted to a number of drawings, of which the best known is a study of an ornate, old-fashioned rocking chair. Tahitian images did, however, fix themselves in Matisse's mind, to re-emerge in the last years of his life, for example in paper cut-outs such as *Polynesia: the Sky* (1946), *Polynesia: the Sea* (1946) and the very late *Memory of Oceania* (1953). Interestingly enough, this island that had so little appeal for Matisse as an artist seems to have enchanted him as a man – although we should hardly think so from his published comments. At any rate he spent three months on Tahiti, where (as he confessed to one correspondent) he was overwhelmed by the newness of it all. Perhaps his retrospective sourness derived from the guilt feelings of a compulsive worker who had, for once, allowed himself to take a holiday. However, he converted his holiday into a round-the-world trip by returning to France via the Suez Canal.

In October 1930 Matisse crossed the Atlantic again, having accepted an invitation to become a member of the jury set up to judge paintings shown at the Carnegie International Exhibition held at Pittsburgh. He was perhaps the more inclined to accept because he had himself been the first-prize winner at the exhibition of 1927. (Whether he voted for the 1930 winner, a portrait by Picasso, is not recorded.) After fulfilling his duties, Matisse left Pittsburgh for New York, from which he visited the two largest collections of his work in the United States: the collection of

MUSIC

Repeats themes from the 1920s showing female figures in similar attitudes.
1939. Albright–Knox Art Gallery, Buffalo, New York.

the Cone sisters in Baltimore (now in the Balti-more Museum of Art) and the Barnes Foundation at Merion Station, Pennsylvania.

The Barnes Foundation had been set up by the patent-medicine millionaire Dr Albert Barnes, whose own house stood next to the Foundation building. He had been collecting Matisse's work since before the First World War, and such important canvases as the *Bonheur de Vivre* (1905–6), *Blue Still Life* (1907), *The Riffian* (1913), *The Music Lesson* (1917) and *French Window at Nice* (1919) hung from the walls of the Foundation, alongside quantities of masterpieces by Cézanne, Renoir, Seurat and other painters of the previous seventy years. Matisse had hardly entered the door – or so the story goes – when Barnes announced that he, Matisse, was the man to paint a great mural for the main gallery of the Foundation.

Barnes explained that the mural he wanted was for a wall space over the french windows that included three large lunettes or arch-shaped areas; it was 47 feet long (about 15 metres) and 11 feet (about 3.3 metres) high from the base line to the tops of the arches. Matisse had never worked on anything approaching this scale before, and he seems to have though the matter over carefully before accepting in January 1931. However, in retrospect his agreement looks like a forgone conclusion, since the commission – which left Matisse complete artistic control – represented a once-in-a-lifetime opportunity such as most artists can only dream of. Futhermore, it came at a time when Matisse's inspiration for easel painting seemed to be drying up; neither 1929 nor 1930 had been fertile years in that respect, although important for sculpture and graphic media. Therefore Matisse may well have felt that the Barnes commission offered the possibility of discovering a new way forward; and it did in fact entail a final break with his style of the 1920s.

Having made up his mind, Matisse rented the largest place he could find in Nice – a one-time film studio – and set to work. As we have seen, he believed that there was a decisive relationship between the size of a picture and its content: change the size (let alone the proportions) and you must change the content. In the case of the Barnes mural, this had several interesting consequences. One was that Matisse did not follow the traditional practice of mural painters and create a small-scale design which could be squared off and transferred mechanically on to the larger surface; when his preliminary sketches and studies were done, he worked straight on to the huge canvas attached to the studio wall. The long and continuous process of adjusting form to colour, and vice versa, had to be done by an exhausting climbing of ladders and clambering on to trestles. However, Matisse devised two labour-saving techniques that were to be of some importance in his later work. In order to draw outlines on the canvas from ground level, he began to use a long bamboo pole tipped with charcoal – a method that also enabled him to achieve a smooth, flowing line, normally possible only on a smaller scale defined by the reach of the artist's arm. And rather than try out a colour and then, if he was dissatisfied, paint it over in a new colour (an incredibly laborious procedure where the areas involved were so large) he cut out the appropriate shape from painted paper and attached it to the canvas, building up a kind of jigsaw that remained in place until Matisse was certain that the scheme would work and the final painting could be done. This is significant as the first example of the cut-paper technique which Matisse was eventually to develop into a separate art form.

Work on the Barnes mural went forward in Nice during the first half of 1931 and the winter of 1931/32. But when the vast canvas was finished and ready to be shipped across the Atlantic, it was

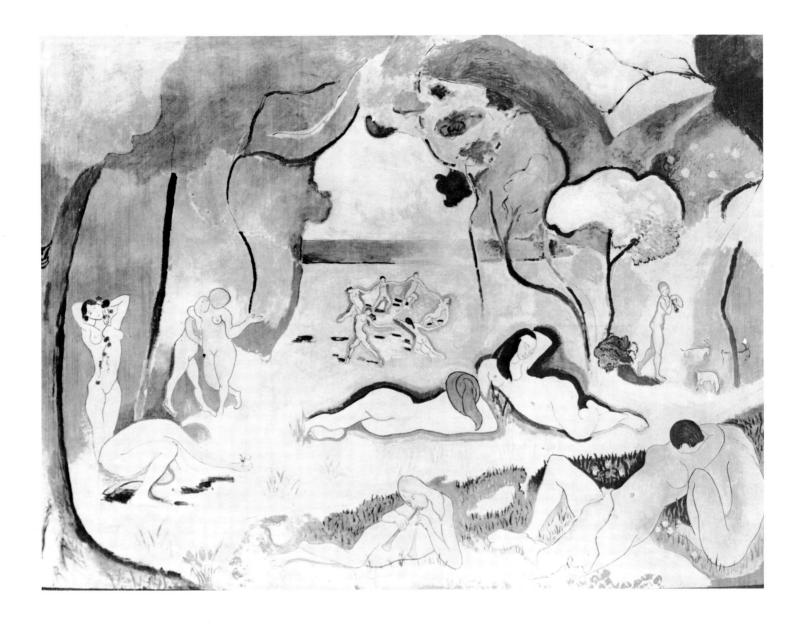

LE BONHEUR DE VIVRE

A monumental work of Matisse's Fauve period, originally titled La Joie de
Vivre *('The Joy of Life') and purchased by the American collector Leo Stein. It
was eventually acquired by Dr Albert Barnes, who retitled it and put it among
the great modern masterpieces he had accumulated at the Barnes Foundation, for
which he later invited Matisse to paint a mural (The Dance,
illustrated on page 102).
1905–6. The Barnes Foundation, Merion Station, Pennsylvania.*

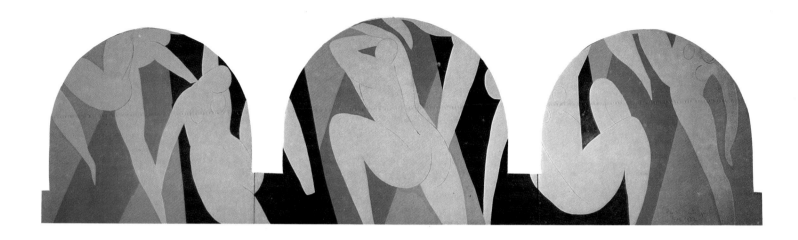

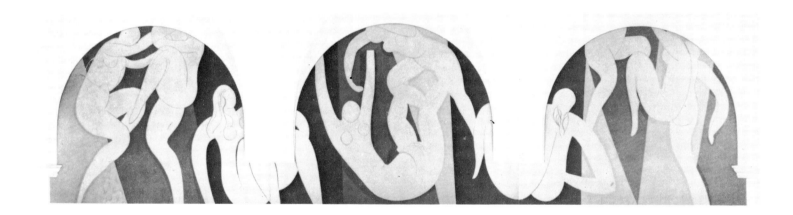

Top

THE DANCE I

The first version of the great mural commissioned for the Barnes Foundation.
When Matisse discovered that the measurements were wrong, he executed an
entirely new version (The Dance II, above), although he probably also did more
work on this one as well.
1931–3. Musée National d'Art Moderne, Paris.

Above

THE DANCE II

Matisse's huge mural was commissioned to fit exactly a prescribed area on the
wall of the Barnes Foundation.
1932. Barnes Foundation, Merion Station, Pennsylvania.

discovered that Matisse had been given the wrong measurements: his mural was over five feet (about two metres) too short. After such intensive labour, Matisse might have been forgiven had he simply inserted a few extra pieces of painted canvas (the 'joins' linking the main arched areas were the parts whose breadth had been under-calculated); many of the world's great paintings have been cut up and stuck together again without the fact being visible to the naked eye. But Matisse, true to his convictions about size, pro-portions and content, made no attempt even to adapt his first design: he set to work again and produced an entirely new mural, finished in April 1932 and later installed on site under his personal supervision. The first version was not, of course discarded, and in fact Matisse seems to have carried out additional work on it during 1932–33. Today, as a result, *The Dance II* dominates the main gallery of the Barnes Foundation, and *The Dance I* can be seen in the Musée National d'Art Moderne in Paris.

In choosing to depict the dance, Matisse re-turned to the subject he had tackled so success-fully in his commission for the Russian collector Shchukin. But the new works were different in both spirit and technique. As his preliminary sketches demonstrate, from the beginning Matisse had in mind a more frenzied, abandoned dance, at first visualized as a circle of rawly coloured figures leaping or sprawling as if taking part in some ecstatic ritual. As work progressed, the colour scheme became cooler and the drawing more refined; both were radically simplified until the figures were outlined, and essential details indicated, with a minimum of means, while the entire painting was executed in flat grey, blues, pinks and black. In the final versions, the dancers (six in *The Dance I*, eight in *The Dance II*) no longer appear in a circle but are more or less paired off. The sense of energy remains strong, however,

since the figures are truncated so that they seem to be leaping out of the painting; furthermore, the 'dance' has developed into something more like a set of no-holds-barred wrestling matches. *The Dance I*, with its lunettes set close to one another, has been given an appropriately tight, powerful, zig-zag diagonal rhythm. In the longer *Dance II*, the rhythm is a more rounded, leisurely, 'bounc-ing-ball' one, created with lines and colour areas that are subtly related to one another and to the sweeping outlines of the lunettes.

The final effect is a curious one: the manic energy of the figures is cooled and refined – one might almost say civilized – by Matisse's use of line, rhythm and colour. Apart from its indepen-dent interest as an original pictorial effect, this two-way pull was singularly appropriate to the intended setting, for the mural had need of energy if it was to establish a visual contrast with the paintings below it (including Cézanne's *The Card Players* and Matisse's *The Riffian*) which are relatively quiet and still; at the same time, it was important that *The Dance* should not overpower them with its sheer size and with violence of movement. In the event, it fulfilled both require-ments while forming a lovely coloured area that held its own with the lush greenery that could be seen through the french windows; the delighted Dr Barnes compared it to the great rose window of a cathedral.

During 1930, the year in which he began the Barnes mural, Matisse started work on a project that was quite the opposite in terms of scale: his first illustrated book. He was invited by the Swiss publisher Albert Skira to illustrate a new edition of the poems of Mallarmé (1842–98), whose elliptical Symbolist verse included the famous 'L'Après-midi d'un faune' and similarly mysteri-ous, evocative, image-rich works. Matisse re-sponded with a series of etchings that possessed an equivalently rich, mysterious poetry; as he

explained, in a singularly lucid description of his methods, the etchings represented a response to the poetry rather than a translation of it into visual terms. He also described the design principle involved. Since the text formed a predominantly 'black' area, the illustration should be 'white'; and that involved etching the thinnest of lines (he used a sapphire-pointed needle), dispensing with shading, and spreading the illustration over the whole page, including the margin, so that there would be no concentration of 'black'. Each double-page spread, said Matisse, resembled a black and a white ball in the hands of a juggler: despite the violence of the contrast, his skill transforms them into a harmonious ensemble. Seen in isolation, Matisse's etchings have an impressive, spare poetry; but (as can be imagined from his own statements on the matter) they need to be seen in context for their full beauty to be appreciated.

One advantage of such a commission was that it impelled Matisse to create images outside his habitual, somewhat restricted repertoire. The Mallarmé poems had called forth, among other items, a swan, a boat, a female head surrounded by a swirling flood of hair, and portraits of Edgar Allan Poe and Baudelaire. Then in 1935 Matisse produced six etchings to illustrate James Joyce's *Ulysses*, a modern classic whose story, set in Dublin, rests on an elaborate parallelism with that of the ancient Greek *Odyssey* by Homer. Matisse selected subjects from the Greek epic poem rather than Joyce's novel – a surprising choice, since the epic was filled with scenes of primitive violence not present in the novel. Thus Matisse etched a *Hercules and Antaeus*, in which Hercules is desperately straining to hold his antagonist clear of the earth from which he draws his strength, and even a *Blinding of Polyphemus*. This last is like nothing else in Matisse's work; we feel the weight behind Odysseus' thrust as he drives a stake into the one eye of the giant Cyclops. This once, Matisse ventured outside the self-created bubble of civilized order in which he lived and worked. The result is sufficient to convince us that his avoidance of violence was a matter of personal taste rather than of incapacity.

By the 1930s it had become common to commission distinguished artists to design not only illustrations but also works for other media that were capable of being reproduced to reach a wider audience than paintings could reach. In 1935 Matisse created a tapestry design – interesting in that it was one of his 'buried' images of Tahiti – and in 1937 he designed a crouching, pipe-playing figure to be engraved on glass for the Steuben Company. However, his greatest years as a popular designer had not yet arrived; they were to come in the 1940s, in spite of the fact that he was by then in his seventies.

BLUE DRESS IN AN OCHRE ARMCHAIR

In the years immediately preceding the Second World War Matisse's work showed considerable variety in both style and choice of subject matter. Drawing became an important element in many of his paintings of this period – mainly of women.
1937. Sonja Henie Collection.

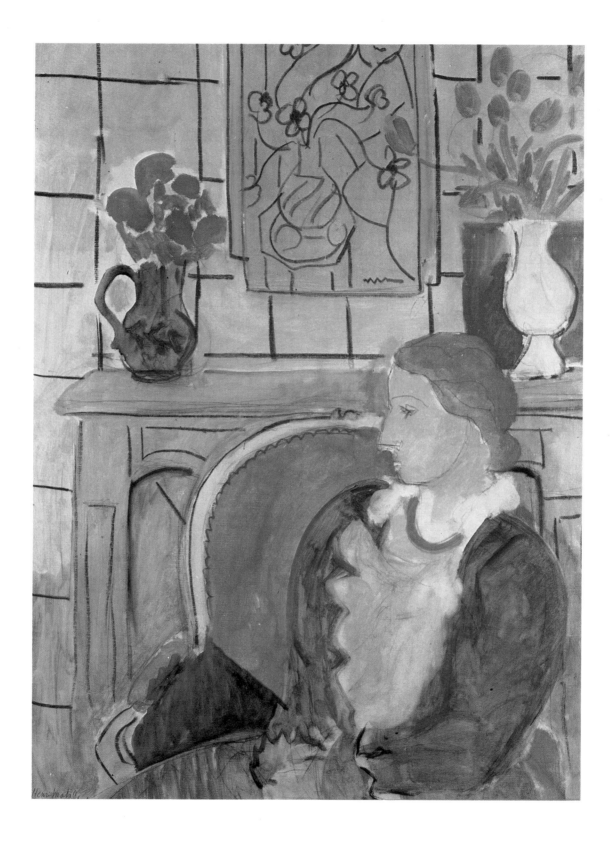

Above left

TIARI WITH NECKLACE

*The tiari is a flower found in Tahiti, where Matisse spent several months. This
bronze sculpture suggests both the flower and the head of a woman.
1930. The Baltimore Museum of Art, Cone Collection.*

Above right

GIRL IN A RUFFLED BLOUSE

*A pen drawing from a period when Matisse was preoccupied with the medium.
Also known as* The White Jabot.
1936. The Baltimore Museum of Art, Cone Collection.

Opposite

THE OCHRE HEAD

*A rather unusual enigmatic painting for Matisse. It may owe something to
Surrealism, but if so it is Surrealism with a very light touch.
1937. Lily Pons Collection, New York.*

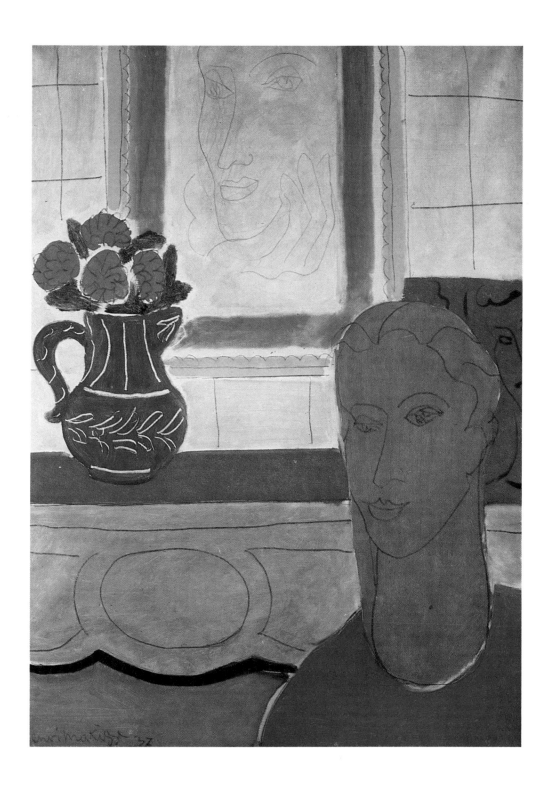

Apart from the Mallarmé and *Ulysses* commissions, Matisse showed only an occasional interest in printmaking during the 1930s. On the other hand, drawing assumed a new importance for him as an art in its own right (that is, as a finished product rather than as a preliminary to painting or sculpture). In particular, the numerous large pen drawings of 1935–36 comprise another splendid tribute to a favourite subject, the nude in an interior. They are more elaborate than is generally the case with Matisse's drawing, and stylistically then seem to owe something to Picasso's graphic work of a year or two before. But Matisse's drawings are more sinuous and more erotic, using decorative studio impedimenta to surround and thus emphasize the model's expanses of voluptuous flesh. One of their most interesting features is the frequent presence of the artist in his own creation – the sort of pleasant game that Matisse had played before, but never so insistently. He appears in various guises – as no more than a hand holding a pen in front of a drawing, for example, as in the superb, sprawling *Nude in a Studio* of 1935, or as an intent observer glimpsed in a mirror. Mirrors, too, occur frequently in these drawings, reflecting either artist or model; but while the artist is never more than a single oblique presence, the model is seen as a double or even a triple image (in the room, in the mirror, in the drawing that the artist is executing). Both the artist's intrusion into his own creation and the levels at which the spectator apprehends the model – as an image and as the image-of-an-image – emphasize the nature of the drawing as an artifact, created by the magician in the mirror. Yet, nevertheless, the experience offered is not a cerebral but an intensely sensual one.

Drawing also became a more important element in Matisse's paintings of the 1930s, which were strongly outlined and inhabited by women with apparently cursory, brush-drawn features.

The quasi-realism of the Twenties has disappeared; the paintings are flatter and more formalized, and although they remain highly decorative it is in a less densely 'oriental' style. Clearly the murals for the Barnes Foundation had proved to be a turning-point in Matisse's development, although none of his subsequent painting aspired to quite the same degree of abstraction. During the Thirties he in fact combined his feeling for attractive interiors, beautiful women and decorative detail with a flat, linear style that owed a good deal to the murals. These also awoke in him a renewed awareness of the role played by the background or 'field' of a picture; for in both versions of *The Dance*, figures and ground were given equal strength and significance. (Only a narrow contour of pink or blue, edging the figures, served to indicate that they were at the front of the scene; the contours, being slightly darker than the pink or blue grounds on which they stood, had the effect of indicating depth without weakening the impact of the background areas.) Matisse shared the characteristic modern feeling, stemming from his admired master Cézanne, that a picture should be a unity – that it is, above all, a two-dimensional surface in which every area should work at full strength on the spectator's eye; and in such a concept, 'background' is as important a part of the surface pattern as 'foreground'. Therefore, in many earlier works Matisse had not hesitated to ignore or play tricks with perspective which, used in proper academic fashion, gave an illusion of depth only by creating a pictorial weakness, fading the tones and blurring the outlines of the 'distant' areas. Although his paintings of the 1920s had been in every way more traditional – which, as we have seen, contributed greatly to their popularity – now, in the Thirties, he again ignored or manipulated 'realistic' spatial effects, 'bringing forward' backgrounds and making

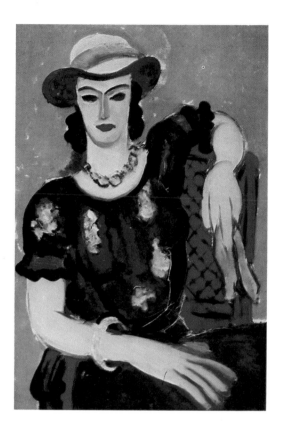

'empty' space 'work', this time within the context of his new style and mood – linear, flattened and cheerfully sophisticated.

An illuminating example of Matisse working in this style is provided by the twenty-two photographs he took of the *Pink Nude* (1935) in progress. These begin with a fairly conventional reclining figure set against a sharply receding room corner, and end with a flattened and greatly enlarged nude (so large that she is spilling out of the picture surface) set among – rather than in front of – conventionalized 'background' elements that are not dominated by the nominal subject but form part of a convincing overall pattern with it.

Most of Matisse's paintings of the 1930s were less stylized than the *Pink Nude*, and indeed most of his pictured women were recognizably 'modern' in hairstyles and clothing. More surprisingly, they were modern in outlook: suddenly the

GIRL IN A RED CHAIR

In Matisse's paintings of the 1930s the 'plaything' women of his 1920s works give way to creatures of character and force such as this one.
1936. The Baltimore Museum of Art.

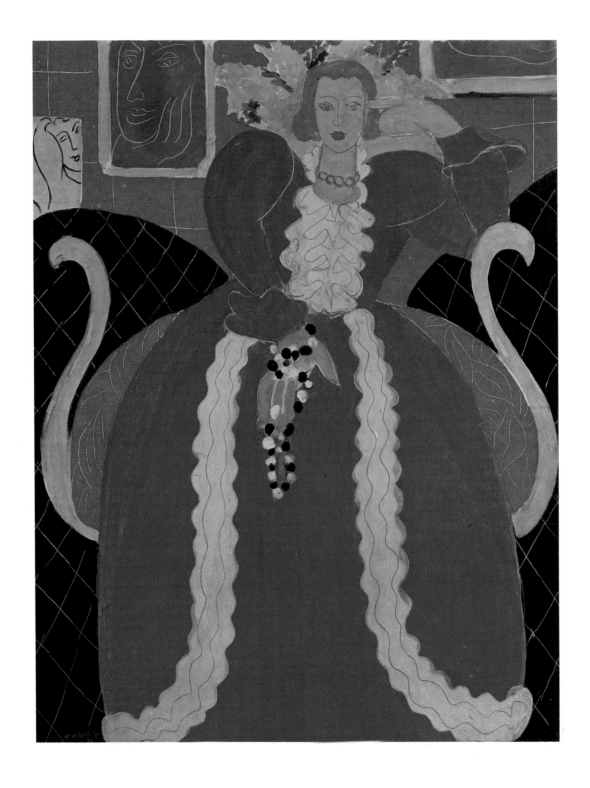

model-as-plaything becomes quite rare in his work, and we are confronted with presence and personality – enigmatic (*The Ochre Head*, 1937), pensive (*Blue Eyes*, 1935), sophisticated (*Odalisque with Striped Gown*, 1937), cheerfully communicative (*Music*, 1939), and even forthrightly self-confident (*Girl in a Red Chair*, 1936). Paintings of this sort are not in any sense character studies, but they do represent a distinct shift in Matisse's response to women, for a reason or reasons unknown. This development cannot be dismissed as an illusion or an accident of social history – a misleading impression of female 'seriousness' derived from square-cut fashions and more assertive make-up – since it also occurred in the pen drawings of 'timeless' nudes we have already mentioned. These may be willing playfellows, but they are too sprightly and come-hither in bearing to pass for the languishing odalisques of the previous decade. The new tendency persists even in the large, intensely decorative 'fancy-dress' paintings in which harp- and vase-shaped women fill the canvases (the gorgeous, almost over-rich *Lady in Blue*, 1937, *The Romanian Blouse*, 1940, *The Dream*, 1940). Although stylized, the models are more than the merely formal or sensual presences that had so often been their role in the past.

In 1938 Matisse was engaged to design the sets and costumes for another ballet, *The Red and the Black* (*Le Rouge et le Noir*), with music by Shostakovich. It was to be performed by the new Ballet Russe de Monte Carlo, whose artistic director, Léonide Massine, had devised and choreographed it. The plot of *The Red and the Black* was a highly symbolic one in which materialistic Yellows struggled against spiritual Blues, with dastardly interventions on the part of Reds and Blacks. Matisse therefore created designs that were appropriately impersonal and unelaborately coloured. The Barnes murals seem to have inspired the high-arched set, while the costumes for both male and female dancers consisted of single-coloured tights enlivened by a few flame-like strips winding about them. Unlike *The Song of the Nightingale* almost twenty years earlier, *The Red and the Black* was performed with some success in 1939 at Monte Carlo and in Paris and New York. Matisse knew Massine well – the two men had worked together on *The Song of the Nightingale* – and at some point Matisse presented him with *The Dancer*, a little picture made on 1 May 1938 out of pasted-down cut-paper shapes. The event is of some historical interest since, although Matisse had continued to use the cut-paper technique for preliminary work (for example, on the *Pink Nude* and on the ballet), this was the first instance of its use as an end in itself. At the time, no doubt, the gesture seemed a charmingly casual one to both giver and recipient.

In the late 1930s there were significant changes in Matisse's way of life. He and Madame Matisse had separated, and in 1938 he moved from his Nice apartment to a suite in the Hôtel Regina, a

LADY IN BLUE

Painted in an opulent decorative style that has been labelled Matisse's 'court'
style. The model was Lydia Delectorskaya, who became the artist's devoted
secretary-companion.
1937. Mrs John Wintersteen, Philadelphia.

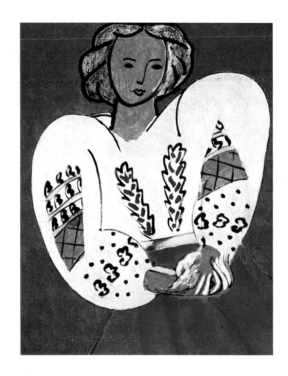

spacious, old-fashioned establishment in the sub-
urb of Cimiez behind Nice. There, in his rooms
above the city, he surrounded himself with the
accumulated treasures of years (ranging from
African masks to his Tabac Royal jar), looked
after a large and exotic aviary that had become one
of his great passions, and even maintained a little
indoor garden.

Although absorbed in his art, Matisse probably
had some consciousness of European events – if
only because his paintings were disappearing
from the museums of Nazi Germany, condemned
along with most other masterpieces of modern art
as 'degenerate'. But the actual outbreak of war in
September 1939 did not immediately affect him;
he visited Geneva, wintered in Nice as usual, and
went up to Paris in the spring of 1940. The end of
the unfought 'phoney war' and the rapid,

humiliating and total defeat of France in May–
June 1940 altered everything, and for a time
Matisse considered leaving the country. He made
his way south via Bordeaux with a visa for Brazil in
his pocket, but finally decided not to use it; he
would, he said, feel like a deserter if he went. Later
he refused offers of a passage to the United States,
despite the presence of his son Pierre in New
York. In the confused conditions of defeat and
flight, he made his way east along the coast until he
reached his home in Nice. Once there, he tried to
immerse himself in painting, hiring as models the
prettiest starlets he could get from a local movie
agent and avoiding circles in which the conversa-
tion was all of war and politics. At seventy it was
not an unforgivable reaction and, besides, he was
tired and his health was poor – much poorer than
he at first realized.

THE ROMANIAN BLOUSE

Another example of the 'modern' woman, a personality in her own right.
1940. Musée National d'Art Moderne, Paris.

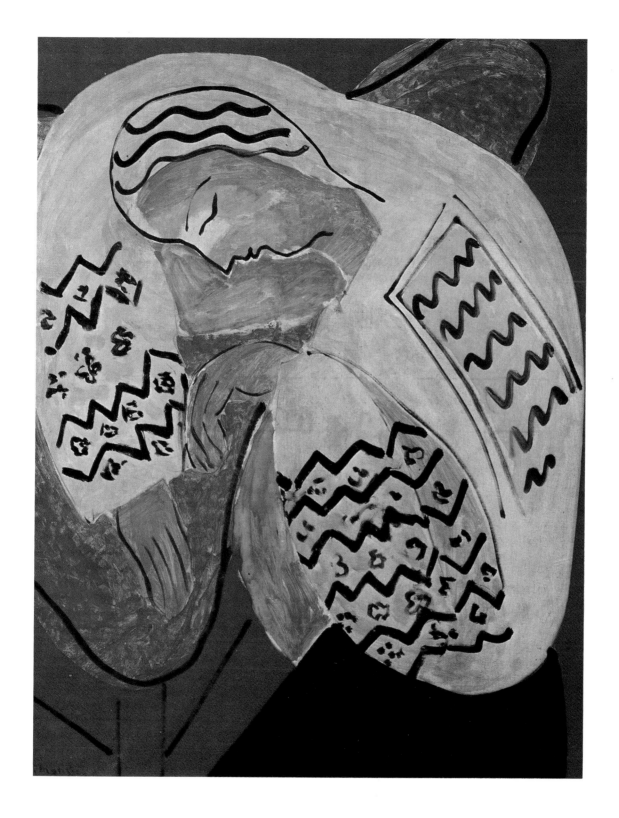

THE DREAM

In this remarkable work the embroidered blouse pattern is again prominent.
1940. Private collection.

113

FRUITFUL
OLD AGE

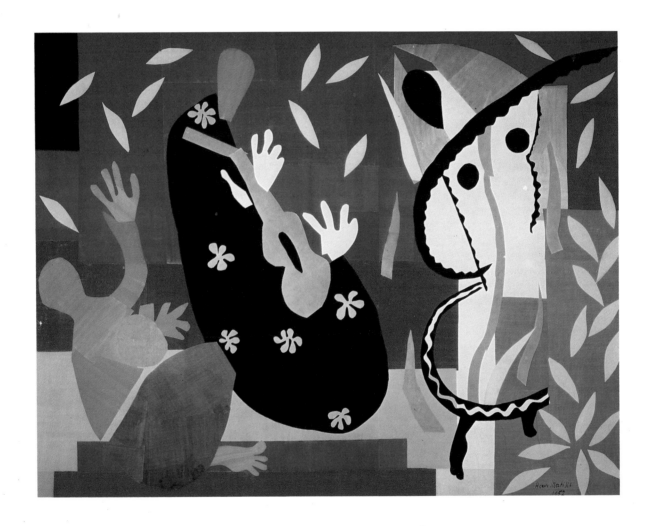

Early in 1941 Matisse was taken to Lyons, where he underwent two serious intestinal operations. In May he was allowed to return and convalesce in Nice, but from this time onwards he was a semi-invalid, with a permanently weakened abdominal wall that made it dangerous for him to stay on his feet for very long. Nevertheless he was comfortable enough under the care of his secretary-companion, Lydia Delectorskaya, formerly the model for the famous *Lady in Blue* (1937) and other paintings. And he could not only draw but paint in bed, his canvas propped up on an extremely large version of the kind of low table used by the habitual breakfaster-in-bed. Somehow or other, in a period of shortages, he acquired sufficient artists' materials (he was even able to help out old friends such as Bonnard and Rouault), and so he went on working as single-mindedly as ever.

If the war influenced Matisse's paintings of the 1940s, there is no sign of it that the outsider can discern. Vichy, air raids, liberation, post-war reconstruction – none of these events left any visible trace on an art that seemingly obeyed only some internal logic of colour and form. There is a considerable variety of mood and style in this period, but the emphasis on flat linear arrangements continues. Matisse's models appear sometimes as lively modern girls in square-shouldered blouses or v-fronted dresses (*The Conversation*, 1941), sometimes as elegant but faceless creatures, mysterious in spite of the vibrantly decorative surroundings (*The Lived-in Silence of Houses*, 1947). The occasional mixing of the two – the faceless swim-suited (?) girl in *Dancer and Arm-chair* (1948) – makes a rather jokey impression. There is a curious spikey contemporaneity, too, in Matisse's still lifes, for example *Red Still Life with Magnolia* (1941), and in his uninhabited interiors (which are in effect large still lifes). The climactic example of these is *Large Interior in Red* (1948), in which Matisse skilfully positions objects against a brilliant all-red background to create a 'room' – and in this he was even more successful than he had been thirty-seven years before in *The Red Studio*.

In the 1940s Matisse's graphic work was as remarkable as his paintings. He had always drawn a great deal, but in 1941–42 he experienced what he himself called an 'efflorescence' (*floraison*): a volume of 200 drawing from this period alone was published in 1943. Other projects tended to be delayed by wartime conditions. For *Pasiphaé*, a volume of poems by Henry de Montherlant, he worked on a series of lino-cuts from some time before the war until their publication in 1944. Using this technique (which entails cutting into linoleum so that the uncut surface prints black), Matisse cut with impressive fluency, creating spare linear designs in white-on-black. He explained that whereas the Mallarmé text had been 'black' and so needed to be balanced by white, the opposite was the case here. Henry de Montherlant's spaciously arranged 'white' text, enlivened with red capitals, was juxtaposed with the predominantly black lino-cut; a generously wide margin pulled together the double-page spread in order to create a visual unit. In effect, Matisse designed the entire volume, just as he had the Mallarmé collection.

THE SORROW OF THE KING

Matisse considered this paper cut-out 'equal to all my best paintings'.
1952. Musée National d'Art Moderne, Paris.

Above

THE IDOL

This is one of a number of single-figure compositions of 1942–3.
1942. Private collection.

Opposite above

LARGE INTERIOR IN RED

The all-red background is converted into a 'room' by the careful positioning
of objects.
1948. Musée National d'Art Moderne, Paris.

Opposite below

RED STILL LIFE WITH MAGNOLIA

One of a number of still lifes which were very modern in conception.
1941. Musée National d'Art Moderne, Paris.

But now his interest in the book as a work of art had become so intense that he wished to make it even more completely his own. In 1941 he conceived the idea of an anthology of love poems by Ronsard, the greatest French poet of the 16th century. Skira agreed to publish it, and Matisse selected the poems and chose the typeface to be used as well as designing the 126 lithographic illustrations. The history of the project was near-tragic; it was bedevilled by difficulties in obtaining the special old typeface that Matisse insisted on, by the German occupation of Vichy France, by the yellowing of the special paper selected, and so on and so on; but in the end all obstacles were overcome and the *Florilège des Amours de Ronsard* was published in 1948.

The Poems of Charles d'Orléans took just as long from conception to final execution, though with fewer mishaps; it was begun in 1942–43 and not published until 1950. For this, Matisse took his involvement a stage further: he not only selected but wrote out in his own hand the 15th-century poems, adding bold lithographic decorations and portraits. The final result, like his earlier ventures in the craft, was a sumptuous masterpiece of book-making.

The logical culmination of these efforts was a book in which the text was not only illustrated and hand-written but also composed by Matisse; and this was duly forthcoming. *Jazz*, begun in 1943 and published in 1947, consists of twenty plates interspersed with Matisse's reflections on art, love and similar topics. He himself insisted that the text was hardly more significant than the fables he had copied to fill clients' dossiers when he was a lawyer's clerk: its function was purely visual, supporting the plates as asters supported the composition of a bouquet with more splendid flowers. There is an element of mock modesty in this disclaimer, but it is true that the words in *Jazz* have very little to do with the pictures. These, as Matisse pointed out, are 'crystallizations of memories of the circus, of folktales or of travel'. They represented a new departure for Matisse as a book illustrator, since they were reproductions of cut-paper works. His mastery of this technique was now apparently complete. The treatment ranged from complete abstraction to figures of the utmost liveliness, executed with wit and fantasy as well as lyricism: in *The Cowboy*, man and animal are linked by a halter in an amusingly balletic grouping; in *The Toboggan*, man and vehicle tumble; in *Icarus*, the mythical bird-man falls limply through space like a creature already stricken; in *The Lagoon*, leaf-like objects float peacefully in a sea of colour. The invention, the energy and the dazzling purity of its colour make *Jazz* one of Matisse's most satisfying creations.

In the postwar years Matisse was involved in more projects than ever. He illustrated a further four books (although none was quite as important as those we have discussed), designed tapestries for the Gobelins and Beauvais factories, designed a rug, designed linen hangings, painted . . . His greatness was now fully recognized, and his public career was a succession of honours and major

THE ROCOCO CHAIR

In the postwar years Matisse devoted his energies to a variety of subjects, although he actually stopped painting in 1948. The Rococo Chair, which was amongst his last paintings, shows strongly marked decorative themes. 1946. Musée Matisse, Nice-Cimiez.

exhibitions devoted to his work.

After 1948, however, he stopped painting and undertook no more commissions for several years: most of his energies were absorbed by a project that he himself considered the crown of his life's work: the Chapel of the Rosary at Vence. His connection with Vence, a small island town roughly twenty miles from Nice, began when he moved there in March 1943, after an Allied air raid had made it seem unwise to carry on living at the Hôtel Regina. The Villa Le Rêve at Vence became his home until January 1949, when he moved back to Regina. Almost opposite the villa was a Dominican rest-home for tubercular girls; and, as chance would have it, one of the nuns,

Sister Jacques, had nursed Matisse immediately after his operations in 1941. Matisse had made a number of drawings of her, and she herself had artistic interests. After her transfer to Vence, Sister Jacques called on Matisse at the Villa Le Rêve to ask his advice about a watercolour design she had devised for a stained-glass window. The window would be part of a new chapel attached to the rest-home, replacing a building that had been destroyed in a fire. Matisse was more than willing to help, and soon became deeply interested in other aspects of the proposed building. Finally, with ecclesiastical approval and a certain amount of professional help from architects, he became responsible for the entire project.

Above

THEME 1, VARIATION 8

*An example of Matisse's great drawing efflorescence of 1941–2; 200 of these,
arranged in 17 'themes' with up to 18 'variations' on each, were
published in 1943.
1942. Bibliothèque Nationale, Paris.*

Opposite

'. . . Ténèbres de moi-même, je m'abandonne a vous . . .'

*One of a series of lino-cuts which Matisse began before the war using a simple
linear design in black on white.
1944. Illustration to Henry de Montherlant's* Pasiphaé.

121

Above

THE BEASTS OF THE SEA

A paper cut-out that suggests the teeming life of the ocean bed.
1950. Private collection.

Opposite

ZULMA

One of Matisse's earliest large paper cut-outs.
1950. Statens Museum for Kunst, Copenhagen.

There followed three years of intensive work until the completion and consecration of the chapel in June 1951. Matisse made a series of models of the building and its contents, and countless preliminary sketches. To work full-scale (as usual) on preliminary designs for the murals, he brought out his charcoal-tipped pole, which he could wield effectively even from a sitting position; and for stained-glass and other designs he brought out his scissors and brightly painted sheets of paper. Given the opportunity to create a 'total' work of art, Matisse designed everything himself: the windows and carved doors, the murals, the marble floors, the choir

THE EGYPTIAN CURTAIN

One of Matisse's last paintings on canvas, it returns to the theme of the relationship between interior and exterior as seen through a window.
1948. The Phillips Collection, Washington.

stalls, the altar and altar-cloth, the bronze crucifix and the candlesticks, even the priests' chasubles.

Matisse, with his passion for simplification, was probably the ideal artist for this task. Although not himself a believer, he respected the function of the chapel and avoided any hint of virtuoso display. Simplicity and lightness are the keynotes, and appropriately so in what is, after all, a modest auxiliary building – a nearly rectangular structure about fifty-one feet (less than sixteen metres) long. Matisse, the great 20th-century colourist, created a predominantly white interior with murals consisting of tiles decorated with large, extremely simplified drawings; the largest of all is a monumental figure of St Dominic, founder of the order. The only exception to this all-pervading large simplicity – and to the tranquillity so characteristic of the artist – is the remarkable *Stations of the Cross*, in which the story of the Passion is condensed into a sequence of fourteen savage, jagged drawings that suggest the scribbled shorthand record made by a horrified observer. By contrast, the crucifix is a fined-down, quiet work in which Jesus, head drooping, is evidently dead: '*consummatum est*'. Apart from the altar, the chief source of colour in the interior is the light filtered through the stained-glass windows, which suggest the colours and forms of nature. The only specifically religious design is a grey fish – one of the earliest Christian symbols – beneath a blue star in one small window.

Matisse was not in any conventional sense a religious man. In *Jazz*, under the question 'Whether I believe in God?' he put the answer, 'Yes, when I work': he had the feeling, common among artists, that he submitted himself to some outside force that made him accomplish things beyond his own powers. But, as he dryly went on to say, he felt no obligations towards a magician whose tricks he could not see through. In his communications with the ecclesiastical authori-

ties, and in his written comments on the chapel, Matisse was extremely tactful, but made it quite clear by implication and omission that his attitude to the project had always been a purely artistic ·one. It says a good deal for the ecclesiastical authorities, of course, that they did not attempt to insist on the artist's doctrinal adherence and that they had overcome the long hostility to modern art on the part of the hierarchy. An even more spectacular example of this occurred at Assy, where Matisse also designed a St Dominic mural (1948) for a church decorated by a galaxy of modern artists (Rouault, Bonnard, Braque, Léger, Lurçat, Lipchitz), of whom one was a Jew and two were card-carrying Communists.

It should be added that Matisse guarded his independence jealously against all comers. His Communist friends included Pablo Picasso and the distinguished poet Louis Aragon, and he agreed when they proposed a large exhibition of his work at a Communist-oriented cultural centre, the Maison de la Pensée Française. In post-war France relations between Party and Church were at their most openly hostile: after inspecting Matisse's designs for the Chapel of the Rosary, Aragon had remarked jokingly – or perhaps only half-jokingly – that the building was gay and attractive . . . and that he and his friends would turn it into a dance-hall when they came to power. Now, for the exhibition at the Maison de la Pensée Française, Matisse insisted on the inclusion of his scale models of the chapel – a gesture by which, in his quietly puckish fashion, he thumbed his nose at two of France's most powerful organizations.

When he had finished work on the Chapel of the Rosary, Matisse, now eighty-one years old, began painting again and embarked on a new series of large drawings, executed with a brush, that have been compared with the calligraphic masterpieces of Chinese art. But the mainstay of his last years was the cut-paper technique, which

enabled him to go on working even when he was bedridden. He had used it to create a number of independent works even while he was engaged on the Chapel of the Rosary, some of which are very large – the nude *Zulma*, for example, and the long, delightful, heart-sprinkled *Thousand and One Nights* (both 1950). Later he was able to go on working on a large scale, for independent compositions such as *Memory of Oceania* (1953) or design commissions such as the stained-glass *Ivy in Flower* (1953), by adapting his technique: he continued to attack the painted papers with his scissors, using Lydia Delectorskaya as his 'hands' to place each item on the canvas according to his instructions.

The technique proved to be the solace of Matisse's old age; it was, he said, the simplest and most direct way he had found to express himself – like drawing with scissors, like cutting without effort into marble for a sculpture. This inevitably makes the technique sound easier than it was: as ever, Matisse proceeded laboriously by trial and error, endlessly changing the shapes and their relationships. But it is true that he did acquire an amazing ability to 'draw' with the scissors, cutting rapidly and fluently into his coloured sheets. Typically, he almost always avoided complete abstraction, although many of his images are only suggestive (of leaves, flowers, birds, fruit) rather

than directly descriptive; and in *The Snail* (1953) the subject is indicated only by the juxtaposition of coloured shapes suggestive of a volute-like pattern of movement. His mastery of figurative art was undiminished, however, as the splendidly strong and accurate *Blue Nude* series (1952) demonstrates; and on occasion it was combined with a vigorous action and sense of excitement such as he had previously shown no great taste for. In *The Swimming Pool* (1952), for example, acrobatic figures leap and plunge above and below the frieze of 'water', while in *The Sorrow of the King* (1952) some more mysterious, almost surrealistic event takes place (Salome dancing before Herod?) in a whirlwind fantasy atmosphere reminiscent of some of the plates in *Jazz* a few years earlier. Such variety and brilliance has perhaps led to an over-valuation of Matisse's cut-outs in relation to his other works, but it is hardly possible to doubt that they introduced something new into the exploitation of pure colour in art.

Matisse went on 'cutting into colour' until the end; his last completed work was a design for a rose window in a New York church. He died on November 3rd 1954. A little later, when Picasso was asked about Matisse-like elements that had appeared in his work, he is said to have replied, 'I have to paint for both of us now.'

Opposite above

APOLLO

*A mythical subject: the sun-god Apollo looks down on a burgeoning vineyard.
1953–4. Moderna Museet, Stockholm.*

Opposite below

WOMEN AND MONKEYS

*Using the paper cut-out Matisse remained a prolific creator even in old age.
1952. Private collection, Paris.*

ACKNOWLEDGMENTS

Photographs: Bibliothèque Nationale, Paris 120, 121; Verlag J. Blauel, Gauting 53; Bridgeman Art Library – Phaidon Press frontispiece, 6, 8, 25, 68, 81, 83, 89, 98, 110; J. E. Bulloz, Paris 112; Hamlyn Group Picture Library 16, 19, 23, 26 below, 38 left, 42 above, 50 left, 88, 113, 116; Hermitage State Museum, Leningrad 74; Michael Holford, Loughton 33, 102 above; Isabella Stewart Gardner Museum, Boston, Massachusetts 32; Musée de Peinture, Grenoble 46; Musées Nationaux, Paris 13, 28 left, 28 centre, 97, 117 below, 114; Baltimore Museum of Art, Maryland 9, 11, 14, 28 right, 42 below, 44, 48, 59, 106 left, 106 right; Museum of Fine Arts, Boston, Massachusetts 31; Museum of Modern Art, New York 60 above left, 60 above centre, 60 above right, 60 below left, 60 below right; Nasjonalgalleriet, Oslo 38 right; Novosti Press Agency, London 67; Philadelphia Museum of Art, Pennsylvania 93; Phillips Collection, Washington, D.C. 124; Pierre Matisse Gallery Corp, New York 69; Statens Museum for Kunst, Copenhagen 36, 39, 47, 50 right, 123; TASS, London 57, 77; Tate Gallery, London 38 centre, 64 left, 64 right, 65 left, 65 right, 91, 92; O. Vaering, Oslo 62; Victoria and Albert Museum, London 94 above, 94 below left, 94 below right; Washington University Art Gallery, St. Louis, Missouri 26 above; John Webb, Cheam 12, 22, 35, 45, 71, 78, 80, 118, 127 above, 127 below; André Held, Paris 105, 107, 109, 122.

The photograph on page 101 and the lower photograph on page 102 are © 1982 The Barnes Foundation, Merion Station, Pennsylvania.

All the illustrations in the book are © S.P.A.D.E.M., Paris 1982 except that on the left of page 38 which is © A.D.A.G.P., Paris 1982.